Constable

Constable

Constable

John Sunderland

Phaidon · Oxford

Phaidon Press Limited, Littlegate House, St Ebbe's Street, Oxford OX1 1SQ

First published 1971
This edition, revised and enlarged, first published 1981
Second impression 1984

British Library Cataloguing in Publication Data

Constable. — 3rd ed.
1. Constable, John, b. 1776
I. Sunderland, John
759.2 ND497.C7

ISBN 0-7148-2158-6
ISBN 0-7148-2132-2 pbk

Printed in England by Jolly & Barber Ltd, Rugby

The publishers wish to thank all private owners, museums, galleries and other institutions for permission to reproduce works in their collections. Particular acknowledgement is made for the following:
Figs. 46, 49 – reproduced by courtesy of the Trustees of the British Museum; Plates 19, 23, 24, 35, 39, 40 – reproduced by courtesy of the Trustees, The National Gallery, London; Plates 5, 15, 16, 32, 33, 41, 43, 46 and Figs. 7, 15, 40, 44 – reproduced by courtesy of the Trustees, The Tate Gallery, London.

Constable

Constable was a painter of the particular rather than the general, the actual, rather than the ideal. 'No two days are alike, nor even two hours; neither were there ever two leaves of a tree alike since the creation of the world.' His greatest originality lies in this belief and in his attempt to enshrine the precise time of day on canvas and the freshness of the English weather. 'I *like* de *landscape* of *Constable* . . . but he makes me call for my great coat and umbrella.' Fuseli's praise of Constable underlines the latter's success in depicting the shifting and watery quality of the weather. For Constable tried to achieve not only truth to nature, truth to what he actually saw in front of his eyes without selection or rejection, but also truth to the atmosphere, in a strictly meteorological sense. He painted the freshness and sparkle of the landscape under sun and rain. He took to heart Benjamin West's advice, 'Light and shadow never stand still'. In a letter to C. R. Leslie, his first biographer, Constable wrote in 1833 that Lady Morley had said of one of his pictures, 'How fresh, how dewy, how exhilarating!' and he added, 'I told her half of this, if I could think I deserved it, was worth all the talk and cant about pictures in the world.'

Constable's is a revolutionary art. In its time it was radical and uncompromising, going against the accepted conventions of his contemporaries and immediate predecessors. Eighteenth-century English landscape painters had produced pictures that were usually generalized and idealized depictions of nature, based on their study of pictures, rather than their study of the actual landscape. Often they were pale imitations or pastiches of Claude; sometimes they derived from the work of Dutch seventeenth-century landscapists such as Ruisdael; always these painters were, in Constable's own words – strictures, in fact, on his own early work – 'running after pictures and seeking the truth at second hand'. They followed certain accepted conventions about how foliage should be painted, how the composition should be built up and organized, what colours should be used, what should be included and what should be left out. Constable rejected all this. He went to nature at its source and tried to forget that he had ever seen a picture before. Like his contemporary, William Wordsworth, he was doing something new, something which had never been done before, and, as Wordsworth had rejected the poetic diction and conventions of the Augustan poets, Constable rejected the pictorial language of eighteenth-century landscape painters. He recognized that he was breaking new ground and realized that his chosen path was hard. In his Preface to the *English Landscape Scenery*, a series of engravings in mezzotint after his work published from 1830, he wrote: 'In art, there are two modes by which men aim at

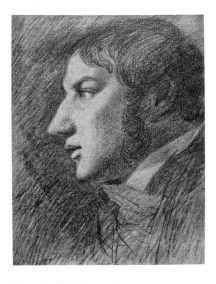

Fig. 1 Self-Portrait

PENCIL, 19 x 14.5 CM. 1806. EXECUTORS OF LT.-COL. J.H. CONSTABLE

distinction. In the one, by a careful application to what others have accomplished, the artist imitates their works, or selects and combines their various beauties; in the other, he seeks excellence at its primitive source, nature. In the first, he forms a style upon the study of pictures, and produces either imitative or eclectic art; in the second, by a close observation of nature, he discovers qualities existing in her which have never been portrayed before, and thus forms a style which is original.'

This is not to say that Constable rejected all the landscape art of the past. He worshipped Claude and Ruisdael and venerated Richard Wilson because he saw in the work of these artists their direct inspiration from nature. It was the copyists and imitators, such as his contemporary John Glover, the 'English Claude', whom he despised. In fact, there is a paradox at the centre of Constable's art. He was a great innovator, but he also wanted to produce paintings that would take their place in the tradition of European landscape art. This is one of the reasons why he laboured at his large six-foot canvases for the Royal Academy exhibitions in the 1820s. He wrote to his great friend, Archdeacon John Fisher of Salisbury, in 1821, '. . . I do not consider myself at work without I am before a six-foot canvas . . . ' His almost lifelong struggle, never perhaps fully resolved, was to produce large exhibition pictures such as the *Haywain* (Plate 23) and the *Leaping Horse* (Plate 37), without losing the spontaneity and immediacy of the first sketch. His usual practice was to work in the summer in the fields, painting directly from nature, normally oil sketches on board or paper, and during the winter and early spring he worked in his studio in London, seeking to inject into his large painting of the year all the vividness and freshness of these sketches.

John Constable was born on 11 June 1776, at East Bergholt in Suffolk, the fourth child of Golding Constable. Golding was a miller who had recently built a substantial house in the village of East Bergholt. He owned mills at Flatford and Dedham and was prosperous. The family and village life in which Constable grew up was of the kind described by Jane Austen in her novels; the social status of Constable's parents was sufficiently high for them to be invited to dine at the large houses in the neighbourhood. When Golding Constable died in 1816 he left an estate worth £13,000. John Constable should have taken over the family business, for this elder brother was mentally deficient, but in fact John's youngest brother, Abram, eventually carried on with running the mills. At the age of seven, John was sent to a boarding school about fifteen miles from East Bergholt and from there he went on to a school at Lavenham where the master in charge is said to have flogged his pupils unmercifully. Constable was taken away and sent to the grammar-school at Dedham, walking to school each day through the shaded lane depicted in the *Cornfield* (Plate 39) in the National Gallery, where he was taught by the able and conscientious Dr Grimwood.

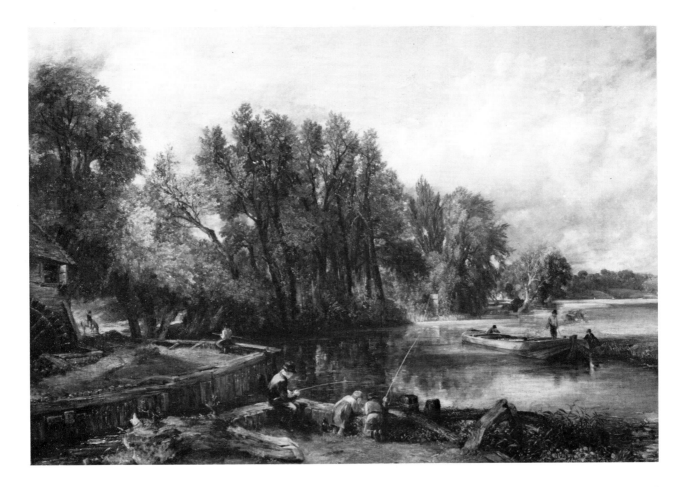

Fig. 2 Stratford Mill

CANVAS, 127 x 183 CM. EXHIBITED 1820. PRIVATE COLLECTION

From the first, Constable felt a deep love for the landscape of the Stour valley, and especially for the small area, about six miles long and two miles wide, around East Bergholt and Dedham. Years later, in 1821, he wrote to John Fisher, ' . . . I associate my "careless boyhood" with all that lies on the banks of the Stour. Those scenes made me a painter, and I am grateful – that is, I had often thought of pictures before I ever touched a pencil.' Although at first intended for the Church, and later working for a year in the mill near Pitt's Farm, which appears in his painting of *Golding Constable's Kitchen Garden* (Plate 12), Constable, from a very early age, wanted to be a painter. He painted in the fields around his home, often accompanied by the amateur artist, John Dunthorne, the father of another John Dunthorne, who later helped Constable in his studio. David Lucas, Constable's engraver, commented on their practice. 'Both Dunthorne [senior] and Constable were very methodical in their practice, taking their easels with them into the fields and painting one view only for a certain time each day. When the shadows from objects changed, their sketching was postponed until the same hour next day.'

Constable's parents, though perplexed by his ambitions, did not fight for long against them. His mother, however, shrewdly realized that his

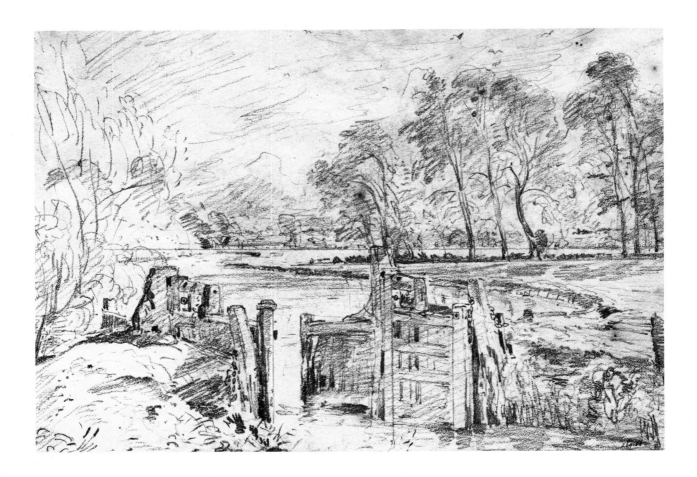

Fig. 3 A Lock on the Stour

PENCIL, 22.5 x 33.3 CM. 1827. LONDON,
VICTORIA AND ALBERT MUSEUM

hopes of making a living from landscape painting were small, and in her letters to him when he was studying in London, and later working as an artist, she continually urged him to look after his own financial interest and encouraged him to concentrate on portraiture. In 1809 she wrote to him, '. . . dear John how much do I wish your profession proved more lucrative, when will the time come you realize!!!' Many artists with ambitions to be landscape or subject painters grumbled that money could only be made from portraiture or 'fiz mongering'. Indeed, even in Constable's lifetime, landscape painting, or at least landscapes of humble and ordinary nature, was not regarded as worthy of a place in the higher branches of art. It is partly a measure of Constable's achievement, which did not bear fruit in his lifetime, that such painting finally became acceptable. It also partly explains why Constable found such difficulty in selling his works. He did try to supplement his income by portraiture, especially before the 1820s, but his heart was not in it.

The years of Constable's boyhood and early youth were crucial for his development as an artist. Throughout his life he returned to East Bergholt in the summer months to draw fresh inspiration from the scenes he knew so well and his finest paintings all depict the Stour valley and other parts of England that he both knew well and which

harboured for him happy associations. He could not, like Turner, go anywhere and paint any landscape or scenery. He needed to be deeply immersed in a place before be could paint it with true feeling and conviction. He wrote to John Dunthorne from London in 1799: 'This fine weather almost makes me melancholy; it recalls so forcibly every scene we have visited and drawn together. I love every stile and stump, and every lane in the village, so deep rooted are early impressions.'

Constable loved not only the landscape of the Stour valley, but also all the human activity and industry connected with it. C. R. Leslie noted that 'His nature was peculiarly social and could not feel satisfied with scenery, however grand in itself, that did not abound in human associations.' This interest in a landscape where man worked in harmony with his surroundings is quite different from the figures in landscapes found in earlier paintings, especially the Italianate ones. In these the figures are either taken from classical mythology or the Bible, and enact some story not especially connected with the scenery, or they are artificially posed figures put in solely as an aid to the composition, to accent a viewpoint or to draw the eye to a particular part of the picture. Constable's figures are not only at home in the landscape, whether working or merely walking, standing or sitting, but they are also placed naturally.

Fig. 4 A Boat Passing a Lock

CANVAS, 101.5 x 127 CM. 1829. LONDON, ROYAL ACADEMY OF ARTS

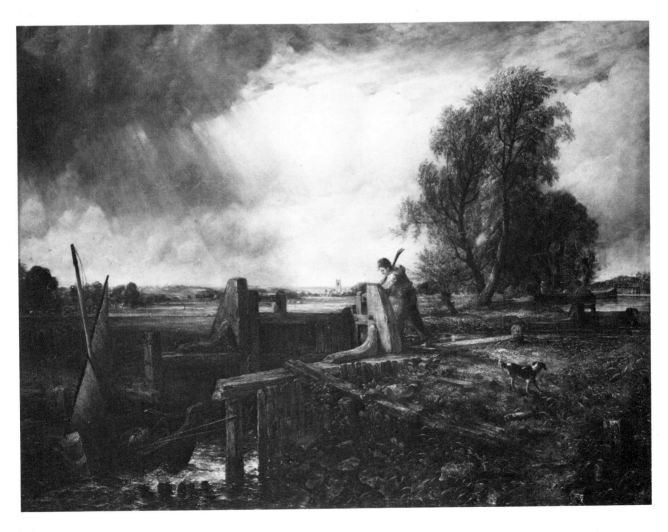

The figures in his Hampstead paintings, such as *Hampstead Heath: Branch Hill Pond* (Plate 42), bear this out. He was especially interested in the activity of the Stour valley. In the *White Horse* (Plate 21), the horse which pulled the barges is being ferried across the river where the towpath crosses from one side to the other, and in the *Flatford Mill, on the River Stour* (Plate 16), the towrope is being unlinked to allow the barges to go under a bridge. In the *Leaping Horse* (Plate 37), the horse which pulls the barges is jumping one of the low fences which keep the cattle from straying. In *Boat-building near Flatford Mill* (Plate 11), a barge is being built by the side of the river, and in *Spring – East Bergholt Common* ploughing is in progress with a windmill on the right. Constable was always at pains to be accurate in his details. He once criticized a painting by another artist on the grounds that the plough depicted in it was not of the sort that was found in the county which was portrayed. His brother, Abram Constable, wrote to Leslie after John's death. 'When I look at a mill painted by John, I see that it will *go round*, which is not always the case with those by other artists.' Constable loved these humble scenes and found in them the subject-matter of all his paintings.

In 1796 Constable met J. T. Smith, best known as the biographer of Nollekens, and his first drawings of cottages, hesitant, ill-drawn and amateurish, are influenced by Smith's depictions of the same subjects. Indeed, Constable's early work is not of high quality, and he was not gifted with easy facility. The rudiments of correct drawing were a struggle and his early paintings are weak in execution. The fact that painting did not come to him easily conditioned his art to a large extent and, paradoxically, accounts for much of the quality in his mature work. For it gives to his painting a directness and integrity and an absence of mannerisms, at least in his finest work, which might well have been lacking had he been an infant prodigy. With Constable, his limitations were also his great strengths. Writing to Dunthorne from London in 1800 he said, '. . . I find it necessary to fag at copying, some time yet, to acquire execution.' When he went to the Royal Academy schools, in 1799, he spent hours producing painstaking and infinitely dull academic nudes, but this practice, though it must have given little encouragement to his teachers, did eventually give him a sound grasp of form.

The early influences on Constable's painting were crucial to his later development. By 1796 he had met Sir George Beaumont, one of his earliest patrons, and later he saw and fell in love with Beaumont's little Claude of *Hagar and the Angel,* which is now in the National Gallery. Beaumont is said to have been so attached to the painting that he had a special box made for it and carried it around with him wherever he went. Constable copied it more than once, and its composition is reflected in *Dedham Vale* of 1802 (Plate 3) and in the larger picture of 1828 in the National Gallery of Scotland. He was also probably introduced to the work of Richard Wilson through Beaumont, whose friendship and

Fig. 5 Hampstead Heath

CANVAS, 38.5 x 67 CM. C. 1820. LONDON, TATE
GALLERY

patronage formed a kind of prototype of the discerning admiration, not
unmixed with perplexity, which Constable found later in the patronage
of Bishop Fisher of Salisbury and even, at times, in the friendship of
Archdeacon Fisher, the Bishop's son. For nearly all of Constable's limit-
ed circle of friends and patrons could not understand why he did not
follow more the practice of his contemporaries.

At this time Constable read Gessner's *Essay on Landscape* and follow-
ed the advice he found in it to copy from landscape engravings. He was
particularly fond of Ruisdael's etchings, which he both frequently
copied and acquired, nearly ruining himself financially in the process.
He met Joseph Farington, the influential *éminence grise* of the Royal
Academy and patron and friend of young artists, who helped him meet
some important people. Constable also admired Gainsborough, and
writing to J. T. Smith from Ipswich in 1799, he said, 'Tis a most
delightful country for a landscape painter, I fancy I see Gainsborough in
every hedge and hollow tree.' Gainsborough's influence can be seen in
some of Constable's early work, such as the *Wood* in 1802 (Plate 2) in the
Victoria and Albert Museum, where the treatment of the foliage and light
staining of the canvas with thin pigment is reminiscent of Gainsborough,
and although his painting gradually lost all similarity to the work of
Gainsborough, Constable retained a great affection for this artist, whose
attachment to landscape and to the Suffolk countryside deeply impressed
him. Although Gainsborough had no interest in the particular, his deep
feeling for landscape is apparent in his paintings. Constable, towards the
end of his life, remarked that Gainsborough's 'object was to deliver a fine

sentiment, and he has fully accomplished it'. Constable's long apprenticeship in his art may seem bewildering when it is set against his obvious originality and rejection of the convention of his time, but he was continually aware of the importance of intelligent study of the art of the past, an awareness which is curtly summed up in his contention of 1836, right at the end of his life, that 'a self-taught artist is one taught by a very ignorant person.'

In 1801 Constable made a tour of the Derbyshire Peak District, but the delicate sketches he made there, although competent and attractive, show no foretaste of what was to come. The year of 1802, though not one of outstanding achievement in his art, marks an important step forward in the development of his ideas and the maturing of his aims and ambitions. The watercolour of *Windsor Castle from the River* (Plate 1), painted in May, with its reminiscences of Samuel Scott and Canaletto, still shows him 'running after pictures and seeking the truth at second hand', but on the 29th of the same month Constable wrote to Dunthorne, 'I shall return to Bergholt, where I shall endeavour to get a pure and unaffected manner of representing the scenes that may employ me . . . There is room enough for a natural painture. The great vice of the present day is bravura, an attempt to do something beyond the truth. Fashion always had, and will have, its day; but truth in all things only will last, and can only have just claims on posterity.' The word 'painture' is that actually written by Constable. It has often been read as 'painter', but Constable probably meant by it 'style of painting' or 'kind of painting' rather than 'painter'. His convictions grew and strengthened, and a year later, he wrote to Dunthorne, 'I feel now, more than ever, a decided conviction that I shall sometime or other make some good pictures.'

Although the next few years in Constable's life are not well documented by his own writings, it is clear that from this time he began to paint direct studies from nature with the aim of putting down exactly what he saw. He did not want any preconceived notions of what a picture should look like, or how it should be painted, to intervene between himself and the landscape in front of him. His method was both scientific and charged with feeling. He sought to find a pictorial language that would approximate as closely as possible to the images which his eye received. This meticulous fidelity to nature can be seen in the two views he later painted from the first-floor window of his father's house at East Bergholt, *Golding Constable's Kitchen Garden* (Plate 12) and *Golding Constable's Flower Garden* (Plate 13) of 1815. It was a long struggle, but particularly noticeable if we follow the sketches he made from about 1802, with *Dedham Vale*, up to the *Boat-Building near Flatford Mill*, exhibited at the Royal Academy in 1815 (Plate 11).

The *Dedham Vale* of 1802 already rejects many well-worn conventions of execution and method, for Constable has already sought to

imitate as closely as possible the different greens in nature and to get away from the predominant brown tone favoured by the connoisseurs. Leslie reported that 'Sir George (Beaumont) recommended the colour of an old Cremona fiddle for the prevailing tone of everything, and this Constable answered by laying an old fiddle on the green lawn before the house.' But *Dedham Vale* still has rather conventional passages, especially in the foliage of the trees, in the flat and uninteresting sky, which is no more than a stage backdrop behind the landscape, and in the composition itself, which derives very closely from Claude's *Hagar*.

In 1806 Constable made a tour of the Lake District, a tour almost obligatory for landscape painters of the time. His oils and watercolours of Borrowdale and Keswick are interesting and significant, because although Constable claimed that the mountains 'oppressed' him, and although he obviously did not feel at home in the awesome grandeur of the Lakes, his work is not like the conventional 'picturesque' views produced by contemporary artists. They are much rougher and freer in handling, emphasizing the weather effects and watery atmosphere of the cloudy mountains. He made notes on the back of many of his sketches referring to the time of day and prevailing weather conditions, a practice which was to continue throughout his life, and notably in the cloud studies of the early

Fig. 6 Brightwell Church and Village, near Woodbridge, Suffolk

OIL ON PANEL, 15 x 23 CM. 1815. LONDON, WILLIAM DRUMMOND COVENT GARDEN GALLERY LTD

1820s. For example, on the back of *View in Borrowdale* (Plate 4), where there is a rough pencil sketch, he wrote, 'Borrowdale 4 Octr. 1806 Noon Clouds breaking away after Rain.'

The next crucial stage comes between 1810 and 1816, when Constable spent most of the summers at East Bergholt, sketching in the fields and surrounding countryside. These were also the years in which his long drawn out courtship of Maria Bicknell was in progress. The *Village Fair* of July 1811, belongs to this period, as do the amazingly direct studies, *Barges on the Stour* (Plate 8) and *Flatford Mill from a Lock on the Stour* (Plate 6), both probably painted between 1810 and 1812. In the last two oil sketches Constable has obviously tried to rid his mind of any preconceived notions about pictures. The brushwork is direct and spontaneous, almost as if he was not aware of it at the time, so engrossed was he at putting down what he saw. The sky in both studies is as thickly and strongly painted as the landscape itself, forming an integral part of the whole. Skies were to become one of the major preoccupations of his mature work. There is none of the conventional, slightly flaccid brushwork which is found in the *Dedham Vale*, but each strong stroke seeks to transmit what he actually saw, to be a visual equivalent of part of the object it depicts. Constable is not interested here in pleasing effects of light, tone and colour; his intense experience before nature is almost crudely transferred to the picture. There is a feeling of direct contact with the landscape and the quality of freshness and sparkle is achieved. One senses, from these studies, that the act of painting was, for Constable, in the final analysis, of more significance than the finished work. Constable himself said that 'Painting is with me but another word for feeling.'

After sketches such as these, the *Boat-Building near Flatford* (Plate 11), exhibited 1815, is another important milestone. Here he aimed to paint, entirely in the open air, and in front of the motif, a finished picture, not merely an experimental study or sketch. It was one of his earliest attempts to inject into a finished picture the direct spontaneity of a sketch. Although the colouring is faithful and the details are individually almost perfect in their fidelity, the whole does not hang together satisfactorily. It is a brilliant accumulation of details, rather than a painting with an overall theme. There is no prevailing source of light which illuminates the separate parts, welding them into a coherent whole. The *Flatford Mill, on the River Stour* (Plates 16—18), of 1817, can be criticized in the same way, but it is more advanced in that the sky is more predominant and governs the prevailing tone of the painting. Constable was continually aware of the importance of the sky in landscape painting. In 1821, quoting Sir Joshua Reynolds, on the landscapes of Titian, Salvator Rosa and Claude, he wrote, 'Even their skies seems to sympathise with their subjects', and continuing with his own thoughts he said, 'I have often been advised to consider my sky as a

"white sheet thrown behind the objects." Certainly, if the sky is obtrusive, as mine are, it is bad; but if it is evaded, as mine are not, it is worse; it must and always shall with me make an effectual part of the composition.'

These early years of development, from 1811 to 1816, formed a springboard from which Constable moved on to his big exhibition pictures, the pictures which he himself regarded as his most important and lasting works. It was during these years that Constable extensively used the oil sketch, sometimes on canvas, but usually on paper or board, which gave a light-brown basis on which to work. The oil sketch was not new, but Constable used it as a more significant working tool than earlier artists. He used it not only, in fact rarely, to work out compositions, as it had mainly been used previously, but almost as an end in itself. I use the word 'almost', because Constable never regarded the oil sketch as a finished picture or as a work that could be exhibited. He felt that it had certain drawbacks, for 'In a sketch there is nothing but the one state of mind – that which you were in at the time.' But he worked out his problems with it, rather as a mathematician might use a blackboard, or as a scientist might use the equipment in his laboratory. Indeed, the comparison with the scientist is not as far-fetched as it might sound: Constable's art was scientific, and his oil sketches can be seen as his experiments. He wrote, 'In such an age as this, painting should

Fig. 7 Mill Stream

OIL ON BOARD, 20.5 x 28.5 CM. 1813–14. LONDON, TATE GALLERY

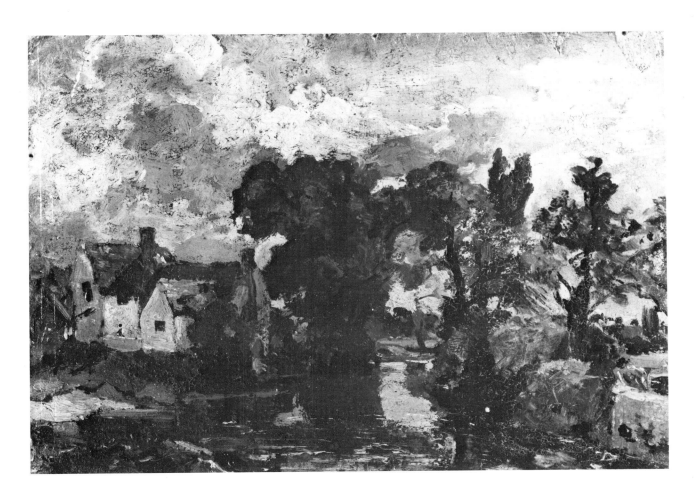

be understood, not looked on with blind wonder, nor considered only as a poetic aspiration, but as a pursuit, legitimate, scientific and mechanical.' Artists before Constable had used oil sketches in much the same way – artists such as the Welsh painter Thomes Jones and the French painter Pierre Henri de Valenciennes – but when these artists had turned to finished pictures they reverted to the standard conventions of the classical Claudian composition. Constable tried to transport into his finished work all the directness of his sketches, almost to draw his large pictures back into the sketch, rather than to merely use his sketches as aids to composing large pictures, or as interesting experiments to be abandoned when a finished picture was taken in hand.

His sketches were rarely composed as one might compose a painting in the studio. Often they are of corners of nature, unsatisfactory as compositions, but effective because of their directness. His *View at Salisbury from Archdeacon Fisher's House* has a cut-off, awkward viewpoint, but it is far more faithful to what we actually see than the most carefully composed painting one could imagine. One can picture Constable sitting at a first floor window looking out on the garden and the trees beyond. There is nothing in the least artificial or selective about the painting.

Although these were early years in his development, Constable was forty in 1816. He married in this year Maria Bicknell after a long courtship which had started before 1811 and which had been relentlessly

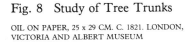

Fig. 8 Study of Tree Trunks

OIL ON PAPER, 25 x 29 CM. C. 1821. LONDON, VICTORIA AND ALBERT MUSEUM

16

opposed by her grandfather, Dr Rhudde, the vicar of East Bergholt and a weighty influence in the village. His married life was extremely happy, shadowed only by the illness of his wife and her early death in 1828, after which Constable's sometimes tetchy nature grew more melancholy and his inward-looking isolation from the world around him grew more marked. Constable, in fact, was never a worldly man in the sense that he found it an easy place to live in. His continual and stubborn refusal to compromise or to sacrifice an ounce of his integrity meant that his relationships with both patrons and contemporary artists was often strained and hostile. Early on in London he made friends with an artist called Ramsay Richard Reinagle, but he soon turned against both Reinagle's art and his friendship. Constable had a biting tongue when roused, and fits of bitterness, together with a nature that could be at times both self-righteous and self-pitying, did not make things any easier. There is some truth in his assertion to Fisher that 'The field of Waterloo is a field of mercy to ours', but there is little doubt that he made the situation worse for himself. He refused to paint as his prospective patrons wanted, even to compromise fractionally, and he always asserted that he painted only for himself; and yet he still desired recognition and was naively pleased if any critic or fellow artist praised his work. But he found solace in his work and his family and few close friends, and these saved him from himself to a certain extent. 'I have', he wrote to Fisher in 1823, 'a kingdom of my own both fertile and populous — my landscape and my children.'

Constable did not make much money from his painting, and certainly not enough to live on until at least the mid 1820s. In the early 1830s he could make as much as £700 or £800 a year, but some of his contemporaries could make as much as this from one painting. In 1816 he was lucky if one of his landscapes made £30, if it sold at all. After his father's death in 1816 he received about £200 a year from the family estate and ironically, his wife inherited a family fortune just before her death, the money of her grandfather, the stern opponent of their marriage. This meant that Constable's last years were spent in financial security.

In 1819 Constable was elected to be an Associate of the Royal Academy. He was not made a full Academician until 1829, when he was in his fifty-third year. Before this he had seen, not without bitterness, lesser and younger men elected, and it is a measure both of the lack of understanding of his art, and of the low esteem in which landscapes of humble nature were held in academic circles, that he had to wait so long. In later life he took part in Academy business and even served on the hanging committee, but he was on the whole cynical about his fellow academicians. But he did recognize that the Academy was the one place where recognition was possible for a living English artist. Patrons preferred conventional pictures; dealers usually only bought and sold 'old masters'; engravers and printsellers took the bulk of the profit from

engravings; but in the Academy Constable's name could become known. In Somerset House, where the exhibitions were held, it was difficult to really see a picture unless it was exhibited 'on the line', the position reserved for academicians, and unless an artist produced large pictures it was unlikely that he would be noticed. This is perhaps one of the main reasons why Constable turned to large pictures in 1819, when he exhibited the *White Horse* (Plate 21) at the Academy. This is a successful picture which shows the closed-in composition of many of Constable's large works. There is no long or distant view, but a close-up of the life of the Stour with trees closing off the composition at the back. It has the natural freshness of all Constable's best work, together with telling detail and rich passages of thick pigment. Fisher recognized its merit and bought it for £100, partly, it must be admitted, out of a desire to help his struggling friend's finances. He wrote to Constable in 1820 when it was installed in his house, 'My wife says that she carries her eye from the picture to the garden and back and observes the same sort of look in both.'

The following succession of large exhibition pictures, meant by Constable to take their place in the great European tradition of landscape painting stretching back to Ruisdael and Claude, were original not only in their handling, but also in their subject-matter. It had previously been thought, especially in England in the eighteenth century in academic circles, that paintings of ordinary nature were not grand enough to be placed in the highest rank or judged by the highest standards. They should be idealized or generalized depictions of nature, and perhaps should be ennobled by figures from classical or biblical history. Sir Joshua Reynolds – the first President of the Royal Academy and greatly venerated by Constable for his services to British art – had claimed that 'common' or 'mean' nature could not form the subject of great pictures. But Constable wanted to paint 'common' nature because he considered it possessed both noble and moral, even divine, elements. He said that there was nothing 'ugly' in nature, and he believed that the more faithfully it was represented, the more noble was the result. It was a conviction which is shown by his admiration for Gilbert White's *Natural History of Selborne,* a study of the natural life in the small village in Hampshire and its surrounding woods. 'The single page alone', Constable wrote, 'of the life of Mr White leaves a more lasting impression on my mind than that of Charles the fifth or any other renowned hero – it only shows what a real love for nature will do . . .'

In 1821 Constable exhibited the *Haywain* (Plate 23) at the Royal Academy. Typically, it was called in the catalogue, *Landscape: Noon,* demonstrating Constable's interest in the precise and particular time of day. Springing from a number of studies and oil sketches, notably of Willy Lott's house, it evolved through the full-size sketch in the Victoria and Albert Museum, and from this time forward it became Constable's

practice to produce a full-size study in preparation for his final exhibited work. Today the *Haywain* is so well known that it is difficult to appreciate its full originality and merit. The composition has all the grandeur of a great picture by Ruisdael, to which it was compared by one newspaper critic, but it has also all the life and vigour, the freshness and sparkle, of a landscape under changing skies. In achieving this freshness, Constable inevitably sacrificed 'finish', that is the detailed surface which was far more popular among connoisseurs of the time. In fact, one of the main contemporary criticisms of Constable was that his pictures were 'unfinished'. Even when he was painting *Salisbury Cathedral from the Bishop's Grounds* for the Bishop, John Fisher urged him to put a little more 'niggle' in it to please his patron. Constable made his feelings plain when he wrote to Fisher in 1823 about *Salisbury Cathedral*. 'I have not flinched at the work, of the windows, buttresses, etc. etc., but I have as usual my escape in the evanescence of the chiaroscuro.'

Fig. 9 Salisbury Cathedral, from
 the Bishop's Grounds

CANVAS, 87.5 x 112 CM. EXHIBITED 1823. LONDON,
VICTORIA AND ALBERT MUSEUM

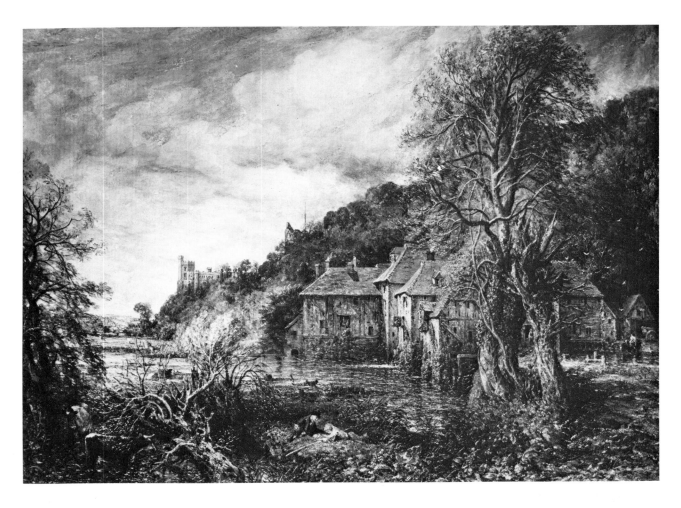

Of his large exhibition pictures, the *Haywain* is Constable's most complete statement of his artistic aims. In it his art reached its high-water mark. If it is not completely successful, it is only because the complete fidelity to nature which Constable hoped to achieve is not possible with paint on canvas. Through the long process of composition and execution some of the spontaneity of the first contact with nature is bound to be lost, but in the *Haywain* the freshness is sustained as far as possible. Thenceforward Constable moved, if anything, away from completely fidelity to nature. His painting becomes more obviously emotionally charged, but also more mannered, and his personal handwriting becomes more and more marked. The almost total accord between artist and landscape found in the *Haywain* is lost and an intermediary element becomes more noticeable, the artist's feelings, passions, and personal handling.

The *Haywain* found more favour in France than in England. Charles Nodier who saw the painting at the Royal Academy in 1821 wrote, 'The Palm of the exhibition belongs to a large landscape by Constable to which the ancient or modern masters have very few masterpieces to put in opposition.' In 1822 Constable wrote to Fisher, 'I have had some

nibbles at my large picture . . . I have a *professional* offer of £70 for it to form part of an exhibition in Paris.' He had originally asked £150 for it, not an excessive price when it is remembered that it represented almost a whole year's work, and was unwilling, as he put it, 'to allow myself to be knocked down by a Frenchman'. The latter was the dealer Arrowsmith, who did eventually buy the picture – together with the *View on the Stour,* exhibited at the Royal Academy in 1822, and a small study of Yarmouth – for £250. The *Haywain* was exhibited at the Paris Salon in 1824, where it won the gold medal. It had been admired by such eminent French artists as Géricault and Delacroix, and there is no doubt that the freshness and naturalism of his paintings influenced some French landscape painters, notably Paul Huet. Between 1824 and 1830 quite a number of his paintings found their way to France, and although the vogue for Constable declined after 1830, his work made an impact on the course of French landscape art much earlier than it did in England, where, even at Constable's death, his work was both little known and generally misunderstood.

Constable's series of cloud studies were executed mainly at Hampstead in 1821 and 1822. These were attempts to understand more fully the actual form and shape of the different types of clouds so that he could bring greater verisimilitude to his finished paintings. They often have detailed notes on the back, such as '5th Sept. 1822, 10 o'clock, morning, looking south-east, brisk wind at west. Very bright and fresh

Fig. 11 View on the Stour near Dedham

CANVAS, 129.5 x 188 CM. EXHIBITED 1822. SAN MARINO, CALIFORNIA, HENRY E. HUNTINGTON LIBRARY AND ART GALLERY

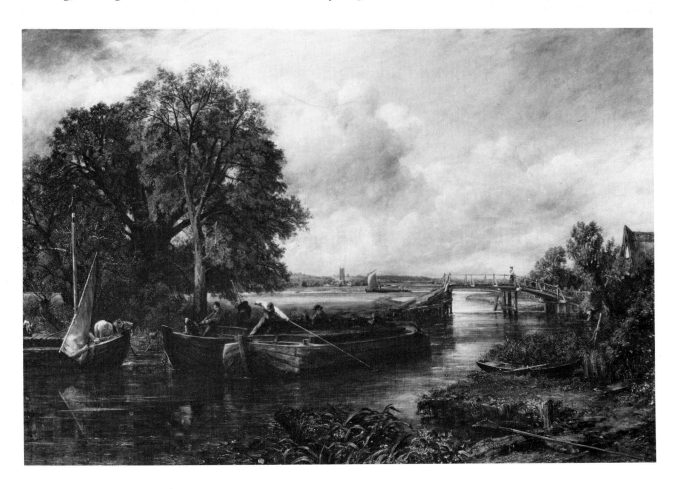

greys clouds running fast over a yellow bed, about half way in the sky. Very appropriate to the Coast at Osmington.' It seems likely that Constable had read Thomas Forster's *Researches about Atmosphere Phenomena*, first published in 1812 and reprinted in 1815 and 1823. From this work Constable would have become familiar with the classification of clouds based on their visible differences of shape. He was, however, not so much interested in their classification as in the accurate depiction of their shapes and colours as they moved across the sky. These scientific sketches of clouds bear out forcibly Constable's contention that the 'sky is the keynote, the standard of scale and the chief organ of sentiment' in a picture. The lessons he learnt by making them can be seen if one compares the *Dedham Vale* (Plate 3) of 1802, with its rather weak two-dimensional sky, with the *Dedham Vale* (Fig. 16) of 1828, where the clouds are recognizable cumulus formations and where the sky casts its light and freshness over the whole picture.

In 1825 Constable exhibited the *Leaping Horse* (Plate 37) at the Royal Academy. The full-size study for the painting is much more worked up and thickly painted than the sketch for the *Haywain*, and there is, in fact, little difference in handling between the sketch and the exhibited work. A comparison between the finished work and the sketch also shows how Constable, notwithstanding his fidelity to nature, was quite prepared to change his composition if he felt that it provided a better balance painting. In the sketch of the *Leaping Horse* a willow tree is on the right of the horse, while in the finished painting it has been moved to the left, and there are changes, too, in the barges on the left and in the left foreground, where a wooden beam is brought into the finished picture to help give the impression of depth and recession into the landscape. But however much Constable changed the composition, the subject-matter remains the same: ' . . . the sound of water escaping from Mill dams . . . willows, old rotten Banks, slimy posts and brickwork. I love such things . . . as long as I do paint I shall never cease to paint such Places.'

Despite Constable's attachment to the Stour valley, he also loved other places which were closely associated with his life and especially his own family; Weymouth and the nearby village of Osmington, where he spent his honeymoon in 1816; Salisbury, the home of his great friend John Fisher; Brighton, where his wife stayed often after 1824 because of her delicate health; and Hampstead Heath, his London home in the late 1820s, where the fresh wind-blown heights above London inspired some of his freshest studies and paintings. Constable never travelled abroad, and had no desire to do so. He made only two major tours in England, and those at the beginning of his career – to Deryshire and to the Lake District.

In 1829 Constable exhibited *Hadleigh Castle* (study, Plate 43) at the Royal Academy. This passionate and tortured painting may well reflect

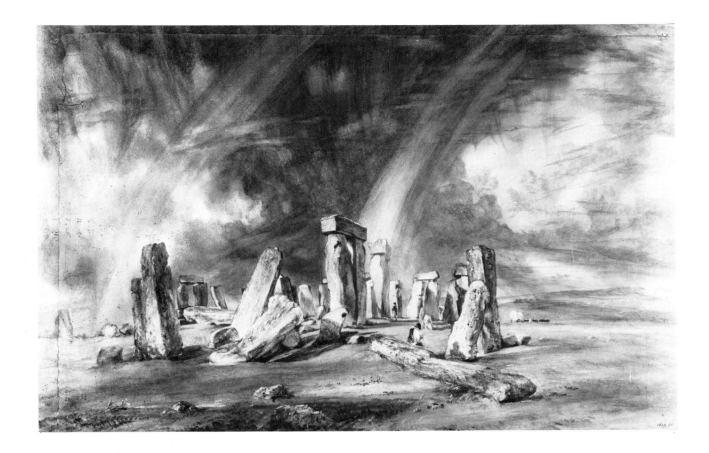

Constable's gloom and despondency following his wife's death the year before. It had its conception in a pencil sketch made in the summer of 1814, perhaps a conscious return to a time of happiness when he was seeking to marry Maria Bicknell against the wishes of her family. Constable, in fact, often returned to earlier sketches for his finished paintings, especially later in his career. The Stonehenge watercolour of 1836 derives from a sketch made in 1820. His *Valley Farm* of 1836 owed its origin to a sketch of 1813, and the *Cenotaph* of 1836, a tribute to Joshua Reynolds, goes back to a drawing made at Coleorton, the country home of Sir George Beaumont, in 1823. Constable may have been trying to recapture the inspiration of his earlier years, when his accord with nature was at its most spontaneous. It is certainly true that his mannerisms grew more marked as the years went by, and he injected into his works an almost feverish movement and passionate intensity that is evident in the brushwork – the staccato stabs of thick paint and the dragged specks of white pigment known as 'Constable's Snow'. He became interested in broad masses of light and shade and less and less interested in the details and fidelity to appearance found in such works as *Flatford Mill, on the River Stour.* This can be seen clearly in the *Trees and a Stretch of Water on the Stour* (Plate 48), painted in the 1830s, where the sepia is applied in such broad masses that no details are apparent at all; and in *A River Scene, with a Farmhouse near the Water's Edge* (Plate 47), also of the 1830s, where

Fig. 12 Stonehenge

WATERCOLOUR, 38.5 x 59 CM. EXHIBITED 1836.
LONDON, VICTORIA AND ALBERT MUSEUM

the later manner of Constable is evident in the broken colour, the thick application of paint, the expressionistic handling and the consistent texture of the whole paint surface, made up of thin underpainting overlaid with dragged passages of thick pure paint. Here we notice not so much the subject of the picture, as the 'manner' of the artist, taking us one remove from appreciation of the landscape depicted and forcing our attention onto the handling. Constable himself was aware of this. He wrote to Fisher in 1830: 'My Wood (Helmingham Dell) is liked but I suffer for want of that little completion which you always feel the regret of – and you are quite right. I have filled my head with certain notions of *freshness* and *sparkle* – brightness – till it has influenced my practice in no small degree, and is in fact taking the place of truth so invidious is manner . . . which should always be combated – and we have nature (another word for moral feeling) always in our reach to do it with – if we will have the resolution to look at her.' This 'manner' was evident in some of the earlier sketches, such as *The Gleaners, Brighton* of 1824 (Plate 32), but it does not become apparent in his finished paintings to any marked degree until after the late 1820s, although its seeds are found in the *Leaping Horse* of 1825.

After 1830 Constable often refers to his love of nature and to his disillusion with painting. In 1831 he wrote, 'Nothing can exceed the beauty of the country – it makes pictures seem sad trumpery . . .' and two years later he made a more violent statement: 'Good God – what a sad thing it is that this lovely art – is so wrested to its own destruction – only used to blind our eyes and senses from seeing the sun shine, the feilds (sic) bloom, the trees blossom, and to hear the foliage rustle – and old black rubbed-out dirty bits of canvas, to take the place of God's own work.' Although Constable here was referring more to the landscapes of other artist, his own feeling of helplessness as an artist is also in evidence. Constable could never abide anything that was unnatural or sophisticated and when he sensed that his own paintings were not as true to nature as he wished he felt a sense of failure. His hatred of the unnatural extended to landscape gardens. He wrote in 1822, 'I do not regret not seeing Fonthill; I never had a desire to see sights, and a gentleman's park is my aversion.' He did paint a few country houses, however, such as the *Malvern Hall* (Plate 5), of 1809, and *Wivenhoe Park*, of 1816. But when he did such paintings, out of obligation rather than by his own wishes, the landscape was more important to him than the house. But he did such topographical work out of need to make ends meet, rather than out of love. When he painted *Englefield House*, in 1833, he had struggles with his patron, Richard Benyon de Beauvoir, and eventually was forced to paint out some cows he had placed before the house and replace them with deer, which were more aristocratic animals and more appropriate to 'a gentleman's park'. This picture was exhibited at the Royal Academy in 1833, and one critic 'told me it was only a *picture of a house*, and ought to have been put into the Architectural

Room.' Constable's reaction was typical in its sharpness and revealing with regard to his ideas. He replied that it was 'a picture of a summer morning, *including a house.'*

It has often been argued that Constable's painting after the *Hadleigh Castle* of 1829 is, in its romantic expressionism, a new departure – a vivid and original last phase of mastery and achievement. His work in these last years certainly has a depth and richness of handling which can be majestic, and in a painting such as *Salisbury Cathedral from the Meadows* of 1831 (Plate 44) Constable uses a broad symbolism that is new in his art. But his complex paintwork, powerful in its effect, is symptomatic also of a personal frustration. After his wife's death in 1828, his private world of happiness gradually became emptier, even though he still derived great comfort from his growing children. John Fisher died in 1832, and his friendship with C. R. Leslie and later his namesake, but no relation, George Constable, never filled the gap. His bursts of temperament increased with age rather than diminished, and even though he discovered Arundel in 1834, and claimed, 'I never saw such beauty in *natural landscape* before', and also found a new patron at Petworth, the Earl of Egremont, all this did not amount to a compelling source of new inspiration. Constable died, at the age of 60, on 31 March 1837.

Constable's major achievements lie in the years of development, from roughly 1802 and especially after 1810, until 1819, when he exhibited his first large 'six foot' canvas, the *White Horse,* at the Royal Academy, and then in the years of maturity of the 1820s, stretching from the *Haywain,* of 1821, up to *Hadleigh Castle,* the beginning of his last phase, in 1829. His art was circumscribed by narrow geographical boundaries and aims that were strictly confined, although intensely pursued. 'My limited and abstracted art', Constable wrote, 'is to be found under every hedge, and in every lane . . .' But Constable has, with Turner, the distinction of being one of the two greatest landscape painters of this country and one of the greatest in the history of art of the whole world. When one looks at the *Haywain,* or the *Gillingham Mill* (Fig. 45), of 1827, with its amazing fidelity to nature, it is easy to think that his art is so obvious as to be almost trite. But in his time he was producing a faithfulness to nature that had never been attempted before in such a consistent and carefully worked out way, nor with such intensity of feeling and thoroughness of execution. The almost inevitable beauty and naturalism of his art is a measure of his achievement. For Constable, like all the greatest artists in landscape, saw something in nature which had never been noticed before and in transmitting what he saw to canvas he enriched and expanded not only subsequent landscape painting, but also everyone's appreciation of the natural scene. It is in part because of Constable that scenes of ordinary nature, fields, streams, trees and river banks under the ever-changing light of the sky, are appreciated and loved, not only in paintings, but also in themselves.

Outline Biography

1776 Born on 11 June at East Bergholt, Suffolk, the son of Golding Constable and Ann Watts, the fourth child and second son in a family of six, three boys and three girls. Golding Constable owns Flatford Mill and a large corn-mill at Dedham. Constable's early interest in painting is fostered by his friendship with John Dunthorne, a plumber and glazier of East Bergholt, and an amateur artist.

1796 Meets J. T. Smith, whose engravings of picturesque cottages influence his early works. By this year he has also met Sir George Beaumont, one of his earliest patrons.

1799 Comes to London in February with a letter of introduction from Joseph Farington. He enters the Royal Academy Schools as a probationer in March.

1800 Enrols as a student of the Royal Academy Schools on 19 February.

1801 Tours the Derbyshire Peak District in August.

1802 Writes to John Dunthorne on 28 May, 'There is room enough for a natural painture.' He buys a studio at East Bergholt and exhibits at the Royal Academy for the first time.

1806 Makes a tour of the Lake District in the autumn.

1810–16 Makes important advances with his oil-sketches, which are mostly executed in Suffolk during the summer months.

1811 Visits Salisbury for the first time in the autumn. His love for Maria Bicknell is made known, but the opposition of her grandfather, Dr Rhudde, the rector of East Bergholt, prevents any hopes Constable has of an early marriage.

1815 Exhibits *Boat-Building near Flatford Mill* at the Royal Academy. His mother, Ann Constable, dies in the spring.

1816 His father dies on 14 May. He is married by his friend John Fisher to Maria Bicknell at St.Martin-in-the-Fields on 2 October and spends part of his honeymoon at Fisher's vicarage at Osmington, near Weymouth.

1817 His first child, John Charles, is born on 4 December.

1819 Exhibits *The White Horse* at the Royal Academy. His second child, Maria Louisa, is born on 19 July. He lives at Hampstead for the first time at the end of the summer. He is elected an Associate of the Royal Academy on 1 November.

1821 Exhibits *The Haywain* at the Royal Academy. His third child, Charles Golding, is born on 29 March. He makes cloud studies at Hampstead in this year and in the following one.

1822 His fourth child, Isabel, is born on 23 August. 35 Charlotte Street becomes his central London house until his death.

1824 Goes to Brighton for the first time with his family in May. A number of his pictures, including *The Haywain*, are exhibited at the Paris Salon, and he is awarded a gold medal for them.

1825 Exhibits *The Leaping Horse* at the Royal Academy. His fifth child, Emily, is born on 29 March.

1826 His sixth child, Alfred Abram, is born on 14 November.

1827 Moves to Well Walk, which remains his Hampstead house until his death.

1828 His seventh child, Lionel Bicknell, is born on 21 January. His wife, Maria, dies on 23 November after many years of delicate health and consumptive attacks.

1829 Exhibits *Hadleigh Castle* at the Royal Academy. He is elected a full Royal Academician on 10 February. He makes his last two visits to Salisbury in July and November.

1830 Publishes the first four plates of his *English Landscape Scenery*, a series of mezzotints after his work by David Lucas.

1832 His great friend, Archdeacon John Fisher, dies on 25 August. His assistant, John Dunthorne, the son of the painting companion of his youth, dies in November.

1833 Gives his first lecture on the history of landscape painting at Hampstead.

1834 Visits Arundel in July. Stays with Lord Egremont at Petworth in September.

1836 Delivers his lectures on the history of landscape painting at the Royal Institution in May and June.

1837 Dies on 31 March.

Fig. 13 **Daniel Maclise, R. A.** (1806–70)
Constable Late in Life

PENCIL, 15 x 11.5 CM. 1831. LONDON, NATIONAL PORTRAIT GALLERY

Select Bibliography

DOCUMENTS AND SOURCES

John Constable's Correspondence, edited by R.B.Beckett, has been published by the Suffolk Records Society in 6 volumes, 1962-1968.

 I *The Family at East Bergholt 1807-1837*, 1962
 II *Early Friends and Maria Bicknell (Mrs. Constable)*, 1964
 III *The Correspondence with C.R.Leslie, R.A.*, 1965
 IV *Patrons, Dealers and Fellow Artists*, 1966
 V *Various Friends, with Charles Boner and the Artist's Children*, 1967

Of these, the volume on the Fishers reveals the most about Constable's attitude to and ideas about his art.

Two further volumes have been published by the Suffolk Records Society:

 John Constable's Discourses, edited by R.B.Beckett, 1970
 John Constable: Further Documents and Correspondence, edited by Leslie Parris, Conal Shields and Ian Fleming-Williams, 1975

BIOGRAPHIES AND MONOGRAPHS

C.R.Leslie, *Memoirs of the Life of John Constable, Esq., R.A.*, 1843. (The earliest biography and still one of the best. A second enlarged edition was published in 1845 and this was the basis for all later reprints, the most recent of which is the edition by Jonathan Mayne (Phaidon), 1980.)

C.J.Holmes, *Constable and his influence on Landscape Painting*, 1902

Phoebe Pool, *John Constable*, 1963

Graham Reynolds, *Constable the Natural Painter*, 1965

Basil Taylor, *Constable: Paintings, drawings and watercolours*, (Phaidon), 1973

R.Gadney, *Constable and his World*, 1976

A.Smart and A.Brooks, *Constable and his Country*, 1976

CATALOGUES

Graham Reynolds, *Victoria and Albert Museum Catalogue of the Constable Collection*, 1960, second edition, 1973

Leslie Parris, Ian Fleming-Williams and Conal Shields, *Constable: Paintings, Watercolours and Drawings*, Exhibition Catalogue, Tate Gallery, 1976. (This catalogue, marking the bicentenary of Constable's birth, is packed with invaluable information.)

The most complete catalogue of Constable's work to date is Robert Hoozee, *L'Opera completa di Constable*, 1979.

A complete catalogue in two parts, by Graham Reynolds and Charles Rhyne, is awaited.

List of Illustrations

List of Colour Plates

1. Windsor Castle from the River
 PENCIL AND RED CHALK AND WATERCOLOUR. 17 MAY 1802. LONDON, VICTORIA AND ALBERT MUSEUM

2. A Wood
 CANVAS. C. 1802. LONDON, VICTORIA AND ALBERT MUSEUM

3. Dedham Vale
 CANVAS. SEPTEMBER 1802. LONDON, VICTORIA AND ALBERT MUSEUM

4. View in Borrowdale
 PENCIL AND WATERCOLOUR. OCTOBER 1806. LONDON, VICTORIA AND ALBERT MUSEUM

5. Malvern Hall, Warwickshire
 CANVAS. 1809. LONDON, TATE GALLERY

6. Flatford Mill from a Lock on the Stour
 CANVAS. C. 1810–11. LONDON, VICTORIA AND ALBERT MUSEUM

7. Golding Constable's House, East Bergholt
 OILS ON MILLBOARD LAID ON PANEL. C. 1811. LONDON, VICTORIA AND ALBERT MUSEUM

8. Barges on the Stour at Flatford Lock
 OILS ON PAPER, LAID ON CANVAS. C. 1810-12. LONDON, VICTORIA AND ALBERT MUSEUM

10. Landscape: Ploughing Scene in Suffolk
 CAVANS. NEW HAVEN, CONNECTICUT, YALE CENTER FOR BRITISH ART (PAUL MELLON COLLECTION)

11. Boat-Building near Flatford Mill
 CANVAS. EXHIBITED 1815. LONDON, VICTORIA AND ALBERT MUSEUM

12. Golding Constable's Kitchen Garden
 CANVAS. 1815. IPSWICH, BOROUGH COUNCIL MUSEUMS

13. Golden Constable's Flower Garden
 CANVAS. IPSWICH, BOROUGH COUNCIL MUSEUMS

14. Willy Lott's House
 OILS ON PAPER. C.1810-16. LONDON, VICTORIA AND ALBERT MUSEUM

15. Maria Bicknell, Mrs John Constable
 CANVAS. 1816. LONDON, TATE GALLERY

16. Flatford Mill
 CANVAS. 1816/17. LONDON, TATE GALLERY

17. Detail from 'Flatford Mill' (Plate 16)

18. Detail from 'Flatford Mill' (Plate 16)

19. Weymouth Bay
 CANVAS. 1816-17 OR LATER. LONDON, NATIONAL GALLERY

20. Waterloo Bridge from Whitehall Stairs
 OILS ON MILLBOARD. C.1819? LONDON, VICTORIA AND ALBERT MUSEUM

21. The White Horse
 CANVAS. 1819. NEW YORK, FRICK COLLECTION

22. Hampstead Heath
 CANVAS. C.1820. CAMBRIDGE, FITZWILLIAM MUSEUM

23. The Haywain
 CANVAS. 1821. LONDON, NATIONAL GALLERY

24. Detail from 'The Haywain' (Plate 23)

25. Study of Hampstead Heath, looking West
 OILS ON PAPER ON CANVAS. 14 JULY 1821. LONDON, ROYAL ACADEMY OF ARTS

26. Cloud Study with an Horizon of Trees
 OILS ON PAPER ON PANEL. 27 SEPTEMBER 1821. LONDON, ROYAL ACADEMY OF ARTS

27. Buildings on Rising Ground near Hampstead
 OILS ON PAPER. 13 OCTOBER 1821. LONDON, VICTORIA AND ALBERT MUSEUM

28. Salisbury: The Close Wall
 CANVAS. 1821? CAMBRIDGE, FITZWILLIAM MUSEUM

29. Branch Hill Pond, Hampstead
 CANVAS. C.1821-2. LONDON, VICTORIA AND ALBERT MUSEUM

30. Cloud Study
 CANVAS. C.1822. LONDON, TATE GALLERY

31. Study of a House amid Trees: Evening
 OILS ON PAPER. 4 OCTOBER 1823. LONDON, VICTORIA AND ALBERT MUSEUM

32. The Gleaners, Brighton
 CANVAS. 1824. LONDON, TATE GALLERY

33. The Grove, Hampstead (The Admiral's House)
 CANVAS. C.1820-5. LONDON, TATE GALLERY

34. Seascape Study with Rain Clouds (near Brighton?)
 OILS ON PAPER ON CANVAS. C.1824-5. LONDON, ROYAL ACADEMY OF ARTS

35. Salisbury Cathedral from the River
 CANVAS. 1820S. LONDON, NATIONAL GALLERY

36. Full-Scale Study for 'The Leaping Horse'
 CANVAS. C.1825-2. LONDON, VICTORIA AND ALBERT MUSEUM

37. The Leaping Horse
 CANVAS. 1825. LONDON, ROYAL ACADEMY OF ARTS

38. Detail from 'The Leaping Horse' (Plate 37)

39. The Cornfield
 CANVAS. 1826. LONDON, NATIONAL GALLERY

40. Detail from 'The Cornfield' (Plate 39)

41. Marine Parade and Chain Pier, Brighton
CANVAS. 1825-7. LONDON, TATE
GALLERY

42. Hampstead Heath: Branch Hill Pond
CANVAS. 1828. LONDON, VICTORIA AND ALBERT MUSEUM

43. Full-Scale Study for 'Hadleigh Castle'
CANVAS. 1829. LONDON, TATE GALLERY

44. Salisbury Cathedral from the Meadows
CANVAS. 1831. PRIVATE COLLECTION

45. View at Hampstead, Looking towards London
WATERCOLOUR. 7 DECEMBER 1833. LONDON, VICTORIA AND ALBERT
MUSEUM

46. The Valley Farm
CANVAS. 1835. LONDON, TATE GALLERY

47. A River Scene with a Farmhouse near the Water's
Edge
CANVAS. C.1830-6. LONDON, VICTORIA AND ALBERT MUSEUM

48. Trees and a Stretch of Water on the Stour
PENCIL AND SEPIA WASH. C.1830-6. LONDON, VICTORIA AND ALBERT
MUSEUM

Text Figures

1. Self-Portrait
PENCIL. 1806. EXECUTORS OF LT.-COL. J.H. CONSTABLE

2. Stratford Mill
CANVAS. EXHIBITED 1820. PRIVATE COLLECTION

3. A Lock on the Stour
PENCIL, 22.5 x 33.3 CM. 1827. LONDON, VICTORIA AND ALBERT MUSEUM

4. A Boat Passing a Lock
CANVAS. 1829. LONDON, ROYAL ACADEMY OF ARTS

5. Hampstead Heath
CANVAS. C.1820. LONDON, TATE GALLERY

6. Brightwell Church and Village, near Woodbridge,
Suffolk
OIL ON PANEL. 1815. LONDON, WILLIAM DRUMMOND COVENT
GARDEN GALLERY LTD

7. Mill Stream
OIL ON BOARD. 1813-14. LONDON, TATE GALLERY

8. Study of Tree Trunks
OIL ON PAPER. C.1821. LONDON, VICTORIA AND ALBERT MUSEUM

9. Salisbury Cathedral, from the Bishop's Grounds
CANVAS. EXHIBITED 1823. LONDON, VICTORIA AND ALBERT MUSEUM

10. Arundel Mill and Castle
CANVAS. EXHIBITED 1837. TOLEDO, OHIO, TOLEDO MUSEUM OF ART
(GIFT OF EDWARD DRUMMOND LIBBEY)

11. View on the Stour near Dedham
CANVAS. EXHIBITED 1822. SAN MARINO, CALIFORNIA, HENRY E.
HUNTINGTON LIBRARY AND ART GALLERY

12. Stonehenge
WATERCOLOUR. EXHIBITED 1836. LONDON, VICTORIA AND ALBERT
MUSEUM

13. Daniel Maclise, R.A. (1806–70): Constable Late in
Life
PENCIL. 1831 LONDON, NATIONAL PORTRAIT GALLERY

Comparative Figures

14. Cottage at Capel, Suffolk
PEN AND INK. 1796. LONDON, VICTORIA AND ALBERT MUSEUM

15. Thomas Gainsborough: (1727–88) View of Dedham
CANVAS. 1750. LONDON, TATE GALLERY

16. Dedham Vale
CANVAS. EXHIBITED 1828. EDINBURGH, NATIONAL GALLERY OF
SCOTLAND

17. View in Borrowdale
PENCIL AND WATERCOLOUR. 1806. LONDON, VICTORIA AND ALBERT
MUSEUM

18. Englefield House
CANVAS, EXHIBITED 1833. PROPERTY OF THE BENYON TRUST

19. Flatford Mill from the Lock
CANVAS. POSSIBLY EXHIBITED 1812. PRESENT WHEREABOUTS
UNKNOWN

20. Two Views of Golding Constable's House
PENCIL ON PAPER. 1814. LONDON, VICTORIA AND ALBERT MUSEUM

21. Dedham from Langham
CANVAS. INSCRIBED '13 JULY 1812'. OXFORD, ASHMOLEAN MUSEUM

22. David Lucas (1802–81): A Summerland
ENGRAVING. PUBLISHED 1831

23. Landscape: Ploughing Scene in Suffolk
CANVAS. EXHIBITED 1814. PRIVATE COLLECTION

24. View on the Stour — probably the Lock at Flatford
PENCIL. 1814 SKETCHBOOK, P. 63. LONDON, VICTORIA AND ALBERT
MUSEUM

25. Wivenhoe Park, Essex
CANVAS. 1816. WASHINGTON, D.C., NATIONAL GALLERY OF ART
(WIDENER COLLECTION)

26. The Mill Stream
CANVAS. C.1814. IPSWICH BOROUGH COUNCIL MUSEUMS

27. Mrs Constable with Two of her Children
OIL ON PANEL. EXECUTORS OF LT.-COL. J.H. CONSTABLE

28. Flatford Mill
PENCIL ON PAPER. 1813 SKETCHBOOK, P.10. LONDON, VICTORIA
AND ALBERT MUSEUM

29. X-ray of detail from 'Flatford Mill'

30. Osmington Shore, near Weymouth
CANVAS. AFTER 1816. PARIS, LOUVRE

31. Whitehall Stairs, June 18th, 1817. The Opening of
Waterloo Bridge
CANVAS. 1832. PRIVATE COLLECTION

32. Detail from 'Salisbury Cathedral from the
Meadows' (Plate 44)

33. Detail from 'Hampstead Heath' (Plate 42)

34. Detail from 'The White Horse' (Plate 21)

35. Study of Sky and Trees, Hampstead
OIL ON PAPER. 1821. LONDON, VICTORIA AND ALBERT MUSEUM

36. Study of Sky and Trees with a Red House, at
Hampstead
OIL ON PAPER. 1821. LONDON, VICTORIA AND ALBERT MUSEUM

37. The Lower Pond, Hampstead
PENCIL AND WATERCOLOUR. 1823. LONDON, BRITISH MUSEUM

38. Salisbury Cathedral Seen from the River
PENCIL ON PAPER. 1823. LONDON, VICTORIA AND ALBERT MUSEUM

39. Branch Hill Pond
CANVAS. 1819. LONDON, VICTORIA AND ALBERT MUSEUM

40. Harwich Light-house
CANVAS. EXHIBITED 1820? LONDON, TATE GALLERY

41. Trees at Hampstead
OIL ON CANVAS. 1821? LONDON, VICTORIA AND ALBERT MUSEUM

42. Detail from 'Coast at Brighton, Stormy Day'
OIL ON CANVAS. INSCRIBED 'BRIGHTON, SUNDAY EVENING,
JULY 20, 1828'. NEW HAVEN, CONNECTICUT, YALE
CENTER FOR BRITISH ART (PAUL MELLON COLLECTION)

43. The Grove, Hampstead
OIL ON PAPER, LAID ON CANVAS. 1821-2. LONDON, VICTORIA AND
ALBERT MUSEUM

44. The Sea near Brighton
OIL ON PAPER. 1826. LONDON, TATE GALLERY

45. Gillingham Mill, Dorset
CANVAS. EXHIBITED 1827. LONDON, VICTORIA AND ALBERT MUSEUM

46. Drawing for 'The Leaping Horse'
CHALK AND INK WASH. 1824-5. LONDON, BRITISH MUSEUM

47. Dedham Vale: Morning
CANVAS. 1811. PRIVATE COLLECTION

48. Hadleigh Castle. The Mouth of the Thames–
Morning, after a stormy night
CANVAS. EXHIBITED 1829. NEW HAVEN, CONNECTICUT, YALE
CENTER FOR BRITISH ART (PAUL MELLON COLLECTION)

49. View over London with a Double Rainbow
WATERCOLOUR WITH SCRAPING-OUT. 1831. LONDON, BRITISH
MUSEUM

50. Drawing of a Tree
PENCIL AND WATERCOLOUR. C.1835. LONDON, VICTORIA AND
ALBERT MUSEUM

51. Cottage at East Bergholt
CANVAS. ?1835-7. PORT SUNLIGHT VILLAGE, LADY LEVER ART
GALLERY

52. A Tree Growing in a Hollow
PENCIL. INSCRIBED 'FITTLEWORTH 16 JULY 1835'. LONDON, VICTORIA
AND ALBERT MUSEUM

Windsor Castle from the River

PENCIL AND RED CHALK AND WATERCOLOUR, 26 x 37 CM. 17 MAY 1802. LONDON, VICTORIA AND ALBERT MUSEUM

This wash drawing was done when Constable was staying at Windsor with Canon Fisher, later Bishop of Salisbury. Constable had been offered a job as drawing master at the Military College at Marlow, but declined the post on the grounds that, as he wrote to John Dunthorne, 'it would have been a death blow to all my prospects of perfection in the Art I love.' This drawing is a neat essay rather in the style of Girtin with echoes of Samuel Scott. In his early years Constable went through a number of phases in his search for a personal style; among his earliest was the 'picturesque' pen and ink technique (Fig. 14) used in the sketches of cottages he made for the antiquarian J. T. Smith in 1796. By the time of the Windsor drawing he had gained in competence, though this is still lacking in any strong originality.

Fig. 14 Cottage at Capel, Suffolk

PEN AND INK, 18 x 30 CM. 1796. LONDON, VICTORIA AND ALBERT MUSEUM

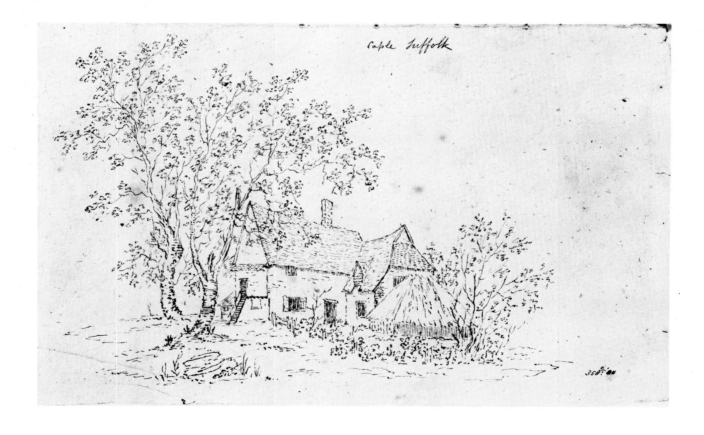

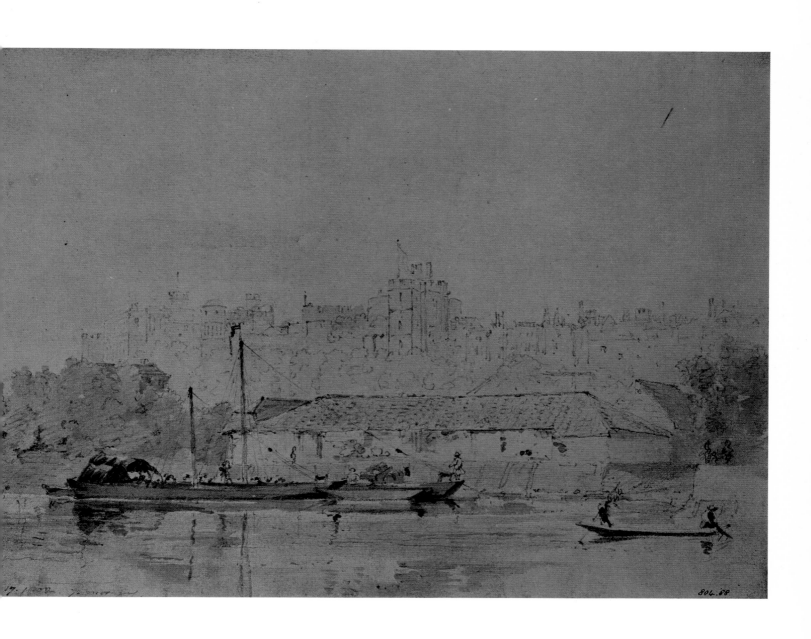

A Wood

CANVAS, 34 x 43 CM. C.1802. LONDON, VICTORIA AND ALBERT MUSEUM

This is presumably one of the oil sketches from nature that Constable made in the Summer of 1802. In technique it is close to the *Dedham Vale* (Plate 3) with the thinly stained brown ground showing through in the foreground, and it shows Constable's early attempts to come to grips with the problem of painting directly from nature out of doors. It may well have been among the sketches that Constable showed to Joseph Farington on 23 March, 1803: 'Constable called & brought several small studies which He painted from nature in the neighbourhood of Dedham.'

The thin paint in the foreground, and the treatment of the foliage of the trees and the clouds, is rather reminiscent of Gainsborough, in such early landscapes as *View of Dedham* (Fig. 15).

Fig. 15 **Thomas Gainsborough** (1727–88): View of Dedham

CANVAS, 62.5 x 78 CM. 1750. LONDON, TATE GALLERY

Dedham Vale

CANVAS, 43.5 x 34.5 CM. SEPTEMBER 1802. LONDON, VICTORIA AND ALBERT MUSEUM

This painting has long been recognized as one among a number of oil sketches done in the Summer of 1802 that mark a significant moment in Constable's career, a stiffening of his resolve to paint faithfully from nature as his central and overriding artistic aim in life, signalled by his letter of 29 May to John Dunthorne (see p. 12). At the same time it is likely that the composition of this painting is based on Claude's *Hagar and the Angel,* which then belonged to Sir George Beaumont and which Constable knew, thus illustrating his dependence both on art and on nature for inspiration. Allowing the brown ground of the prepared canvas to show through, Constable painted the foreground with thin strokes and dabs of paint, partly reminiscent of Gainsborough's method, while the background and sky is painted with longer and wider strokes, almost completely covering the ground. The technique is still hesitant but Constable is beginning to work out a personal vocabulary of brushwork. He used the same composition much later as a large scale finished work, in the *Dedham Vale* of 1828 (Fig. 16).

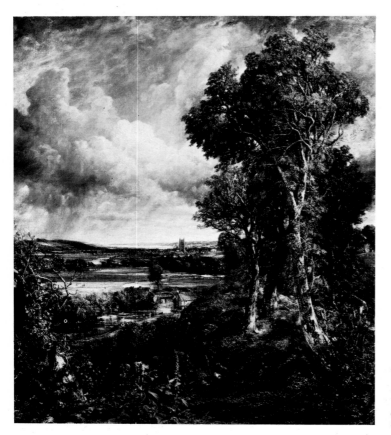

Fig. 16 Dedham Vale

CANVAS, 145 x 122 CM. EXHIBITED 1828. EDINBURGH NATIONAL GALLERY OF SCOTLAND

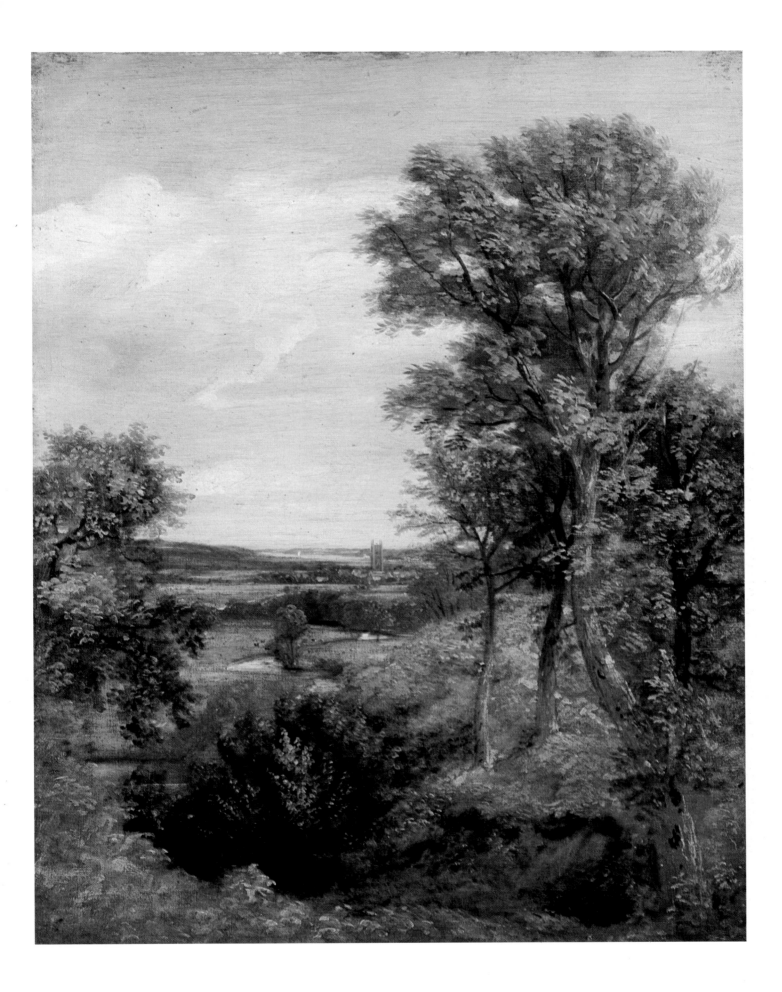

View in Borrowdale

PENCIL AND WATERCOLOUR, 14 x 38 CM. OCTOBER 1806. LONDON, VICTORIA AND ALBERT MUSEUM

Constable's visit to the Lake District in the September and October of 1806 was the kind of trip a landscape painter of the time might have been expected to make, when the 'picturesque' tour was in fashion, but it was arguably his last visit to look explicitly and actively for landscape to paint. After this he found his subject matter in or near the places where he lived or visited friends and relations. The trip was probably financed by his uncle, David Pike Watts. A pencil sketch on the back of this watercolour is inscribed, 'Borrowdale 4 Octr. 1806 Noon Clouds breaking away after Rain'.

Constable was already taking a strong interest in the transitory effects of weather and trying to capture those effects. This sense of movement, of clouds, of light, of colour, against the solidity of the mountains, drew out of Constable quite original and dramatic attempts, mainly in watercolour, to depict the scenes he saw and probably helped to further set himself free from the conventional styles that he was being advised to follow. But he was still aware of the old masters and relating nature to art. He wrote on the back of *View in Borrowdale* (Fig. 17): '4 Oct 1806 – Dark Autumnal day at noon – tone more blooming [than] this . . . the effect exceeding terrific – and much like the beautiful Gaspar [Poussin] I saw in Margaret Street.'

Fig. 17　View in Borrowdale

PENCIL AND WATERCOLOUR, 24.5 x 34.5 CM. 1806. LONDON, VICTORIA AND ALBERT MUSEUM

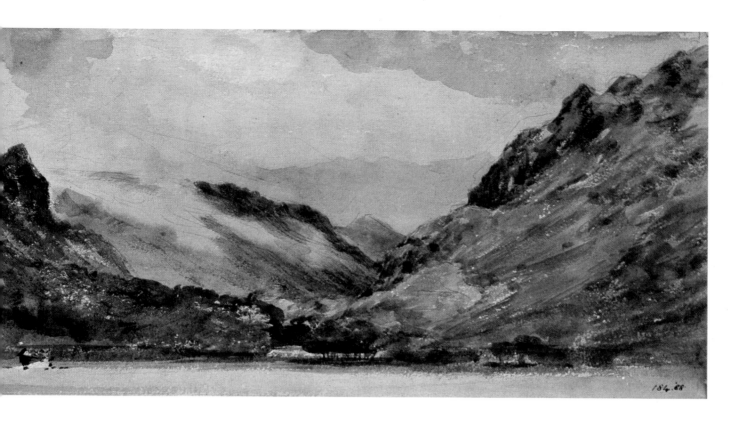

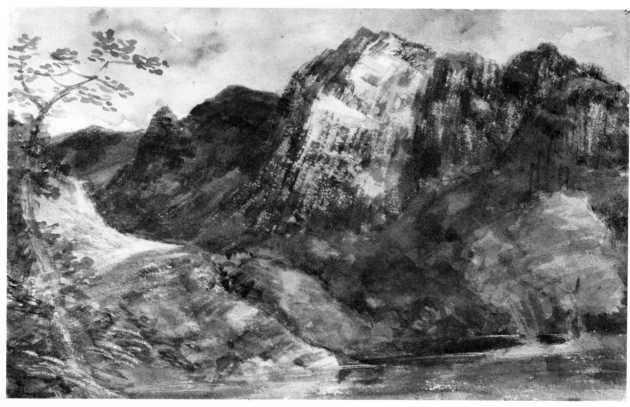

Malvern Hall, Warwickshire

CANVAS, 51.5 x 76.5 CM. 1809. LONDON, TATE GALLERY

Constable visited Malvern Hall, the home of Henry
Greswolde Lewis, twice, in 1809 and 1820. Although there
has been some confusion about the dating of this picture, it
now seems clear that from the point of view of both style
and documentary evidence it was painted in the earlier
year. Constable met Lewis through the latter's sister, the
Dowager Countess of Dysart, and just previously Con-
stable had been employed by the Eighth Earl of Dysart to
copy Joshua Reynolds's portraits of the family and to make
some new ones. Constable was commissioned to paint a
portrait of Lewis's young ward, Mary Freer, and it was pro-
bably for this purpose that he visited Malvern Hall. Con-
stable was thus at this time bound up with the, for him,
relative drudgery of portraiture. This painting was pro-
bably an uncommissioned view, which may appear
strange, given Constable's aversion to country house paint-
ing, but here the landscape dominates and the house appears
only as a background feature.

Much later, Constable was commissioned by Richard
Benyon de Beauvoir to paint Englefield House in Berkshire
(Fig. 18). The painting was exhibited at the Royal
Academy in 1833, and his struggles with his patron and the
difficulty he found in squaring his own art with house pain-
ting are mentioned in the text, pp. 24 – 5.

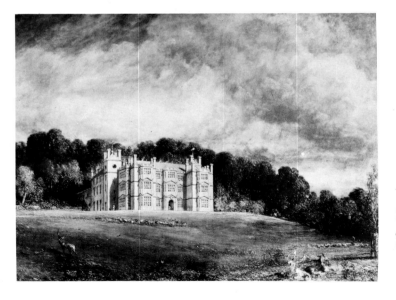

Fig. 18 Englefield House

CANVAS, 103 x 131.5 CM. EXHIBITED 1833, PROPERTY OF THE
BENYON TRUST

Flatford Mill
from a Lock on the Stour

CANVAS, 25 x 30 CM. C.1810–11. LONDON, VICTORIA AND ALBERT
MUSEUM

Constable produced a number of oil studies of this view, with minor variations, which all appear to have been painted in either the summer of 1810 or possibly 1811. They are connected with a finished painting of the same composition, which was probably exhibited at the Royal Academy in 1812 (Fig. 19). We know from a letter Constable's mother wrote to the artist on 26 October 1811, that he was working on a finished painting of this subject. As usual she, like most of Constable's other advisors, was keen to stress the importance of detailed finish. 'Your pretty view . . . is so forward, that you can sit by the fireside and finish it, as highly as you please.' In this case one or all of the oil studies was clearly used as a basic compositional guide for the finished work, but this was not always the case, the relationship between the finished work and the oil sketch being often difficult to explain in purely functional terms. What is clear is that the act of painting such direct studies was tremendously important to Constable and that they served as a help to him in sustaining in the finished work the immediate look and feel of nature.

Fig. 19 Flatford Mill from the Lock

CANVAS, 66 x 92.5 CM. POSSIBLY EXHIBITED 1812. PRESENT WHEREABOUTS
UNKNOWN

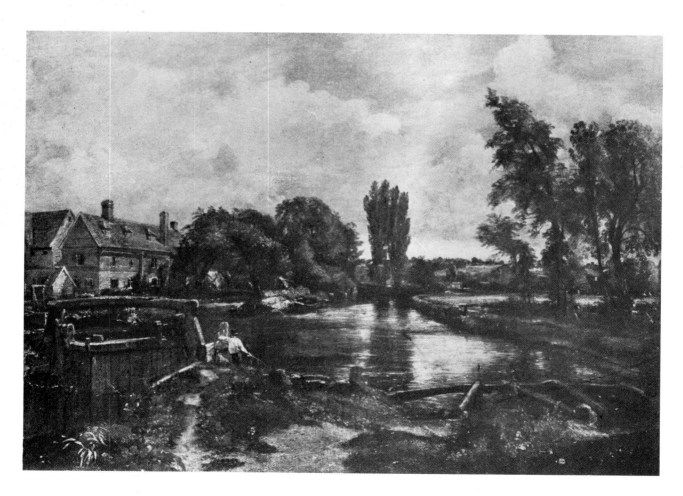

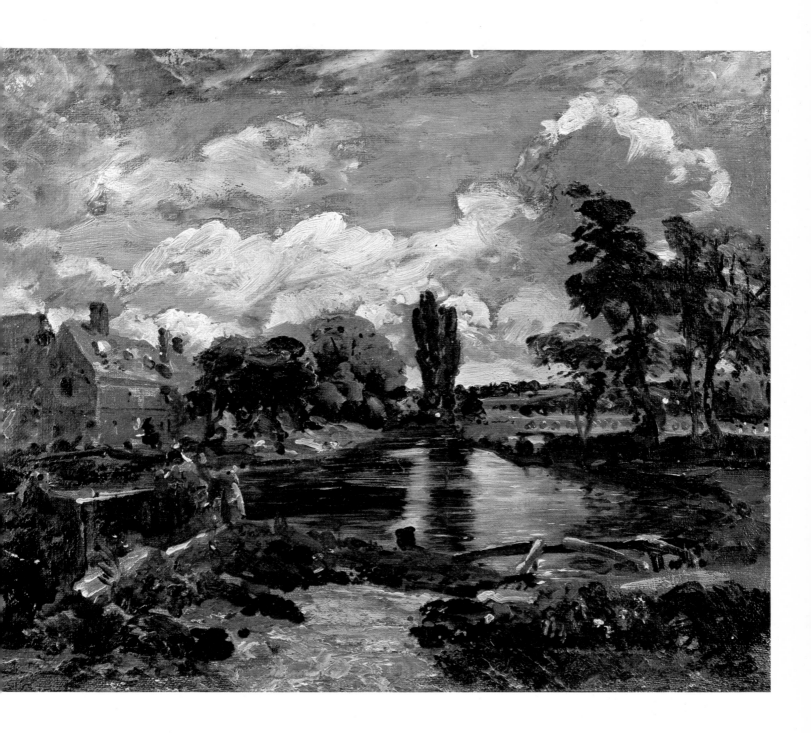

Golding Constable's House, East Bergholt

OILS ON MILLBOARD LAID ON PANEL, 18 x 50 CM. C.1811. LONDON,
VICTORIA AND ALBERT MUSEUM

This wide angled view shows the garden side of Golding
Constable's house, which had been built in 1774 and in
which the painter was born in 1776. Constable later
painted two views from an upstairs room looking out over
the garden and the neighbouring fields (Plates 12,13). It is
the house in which his childhood and youth were spent.
The painting appears to have been folded or possibly cut
down the middle at one time, with the left side having
suffered more damage than the right.

A drawing of the house, shown by moonlight and
sunlight, dated 2nd and 3rd October 1814 (Fig.20) possibly
was part of the 1814 sketchbook, but if so the page was
detached. The back of the drawing is inscribed in pencil
'The House in which J.C. was born'.

Fig. 20 Two Views of Golding Constable's House

PENCIL ON PAPER, 11 x 8 CM. 1814. LONDON, VICTORIA AND ALBERT MUSEUM

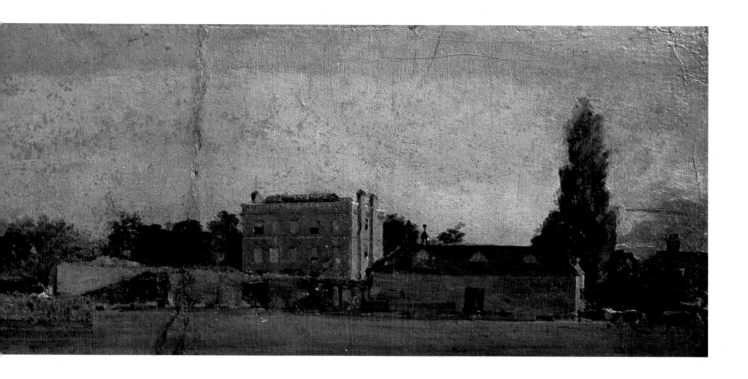

8

Barges on the Stour at Flatford Lock

OILS ON PAPER, LAID ON CANVAS, 26 x 31 CM. C.1810–12. LONDON, VICTORIA AND ALBERT MUSEUM

In the period from about 1809 to 1816, and particularly from 1810 to 1812, Constable's oil sketches from nature achieved a maturity, vigour and originality, which testify to the development of a soundly based personal style. The brushstrokes, though too broad to be strictly speaking descriptive, provide visual equivalents for natural objects and the feel of weather effects which make an immediate impact on the spectator just as they had been executed with immediacy. He prized his sketches and 'He used to say . . . that he had no objection to part with the corn, but not with the field that grew it.' This sketch shows clearly the crossbeams of Flatford Lock, which appear in the background of *Flatford Mill* (Plate 16).

Autumnal Sunset

OILS ON PAPER ON CANVAS, 17 x 34 CM. C.1812. LONDON, VICTORIA AND ALBERT MUSEUM

Painted in the fields near East Bergholt, it was said that the tree on the left in the middle distance was known to Constable and his painting companion, Dunthorne, as the 'wig tree' because of its shape. Constable was obviously attached to this long horizontal composition, for much later he chose this sketch for the mezzotint engraving by David Lucas, entitled 'Autumnal Sunset', which was published in his *English Landscape Scenery* in June 1832, a series of engravings that he saw as a didactic expression of his landscape art. Another similar kind of view, *Dedham from Langham* (Fig. 21), dated 13 July, 1812, is very close to the probably later oil sketch in the Victoria and Albert Museum that he made for his *English Landscape Scenery*, engraved as 'Summer Morning' and published in September 1831. The distant view of Dedham church from Langham was a favourite of Constable's, for in the text to the plate of 'Summer Morning' he wrote that 'the elegance of the tower of Dedham church is seen to much advantage, being opposed to a branch of the sea at Harwich, where this meandering river the Stour loses itself.'

Fig. 21 Dedham from Langham

CANVAS, 19 x 32 CM. INSCRIBED '13 JULY 1812'. OXFORD, ASHMOLEAN MUSEUM

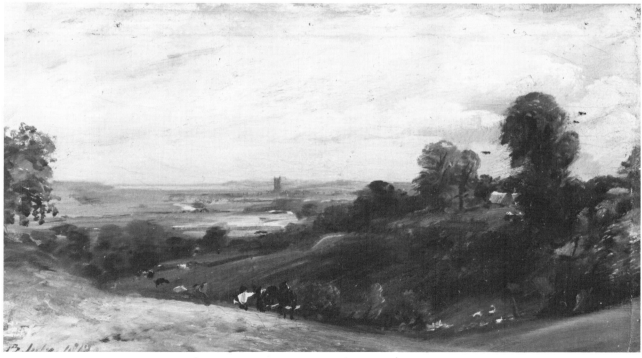

Landscape: Ploughing Scene in Suffolk

CANVAS, 42.5 x 76 CM. NEW HAVEN, CONNECTICUT, YALE CENTER FOR BRITISH ART (PAUL MELLON COLLECTION)

In 1814 Constable exhibited at the Royal Academy 'Landscape: Ploughing Scene in Suffolk' (Fig. 23), a view taken from just outside the grounds of Old Hall, East Bergholt, looking across the Stour Valley. It was bought, either at the exhibition or within the next two years, by John Allnutt, who subsequently asked another artist, John Linnell, to repaint the sky 'as I did not quite like the effect'. Regretting this later, Allnutt got in touch with Constable and asked him to restore the original sky and make some alterations to the size of the painting, but Constable decided instead to paint another version and this is the painting illustrated here in colour. Constable did this free of charge, which may seem strange, especially as one might have expected him to be annoyed that another artist had altered his work. But Constable was grateful to Allnutt for 'buying the first picture he had ever sold to a stranger; which gave him so much encouragement that he determined to pursue a profession in which his friends had great doubts of his success.' The account is related by Leslie, to whom Allnutt had written, telling him of the story.

The original (Fig. 23) was engraved in mezzotint as 'A Summerland' for the *English Landscape* series (Fig. 22) and published in 1831.

Fig. 22 **David Lucas** (1802–81): A Summerland

ENGRAVING. PUBLISHED 1831

Fig. 23 Landscape: Ploughing Scene in Suffolk

CANVAS, 51.5 x 77 CM. EXHIBITED 1814. PRIVATE COLLECTION

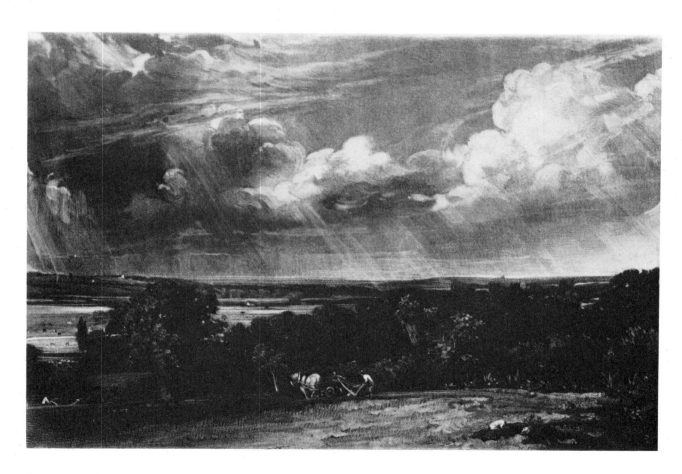

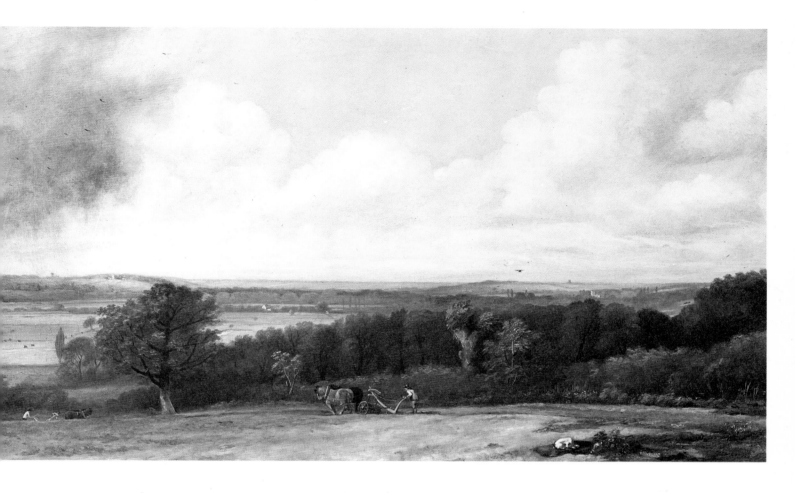

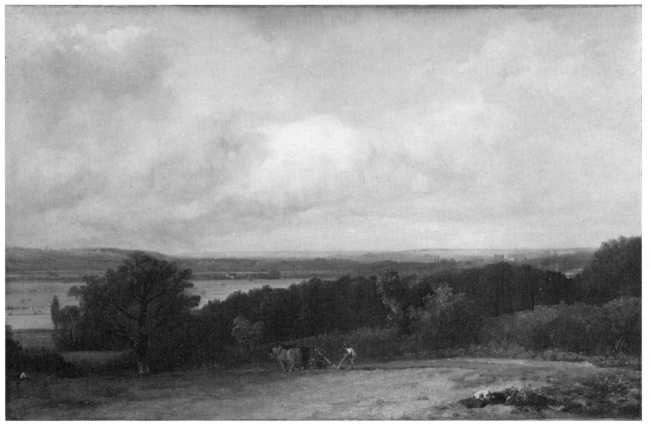

Boat-Building near Flatford Mill

CANVAS, 51 x 61.5 CM. EXHIBITED 1815. LONDON, VICTORIA AND ALBERT MUSEUM

The painting shows a barge being built in Constable's father's boatyard, just by Flatford Mill. On the left the beams of Flatford Lock can just be seen, and the forked tree on the other side of the river appears again, but in a sad state, in *Flatford Mill* (Plate 16, and details, Plates 17,18) of 1817. This gives an idea of how close together the location of many of Constable's Stour scenes are. *Boat-Building* was exhibited at the Royal Academy in 1815 and was painted in the late summer and early autumn of 1814. A pencil sketch for the composition dated 7 September 1814 appears in the 1814 sketchbook in the Victoria and Albert Museum. Another page from the same sketchbook, showing Flatford Lock and the sluice gate, which filled the boatyard, is illustrated (Fig. 24). We also know that Joseph Farington advised Constable in July of the same year to look at the Angerstein Claudes, later to enter the National Gallery, to study their 'finishing', that is their careful detail. Nonetheless, despite the preliminary drawing and Constable's study of Claude to improve his own painting, C.R. Leslie wrote that the *Boat-Building* was 'one which I have heard him say he painted entirely in the open air'. He seems to have worked on the picture in the afternoons for Lucas says that Constable told him 'he was always informed of the time to leave off by the pillar of smoke ascending from a chimney in the distance that the fire was lighted for the preparation of supper on the labourers' return for the night'. It is one of the few examples where Constable painted a carefully finished and exhibited work completely, or almost completely, in front of the motif, and it was seemingly an attempt to combine fidelity to actual appearances with the careful finish which his contemporaries said his work lacked. As such, it marks an important stage in his development, when he was searching to find a style that could both satisfy his own desire for naturalism and provide for the exhibition-going public an acceptable representation of that naturalism.

Fig. 24 View on the Stour – probably the Lock at Flatford

PENCIL, 8 x 11 CM. 1814 SKETCHBOOK, P. 63. LONDON, VICTORIA AND ALBERT MUSEUM

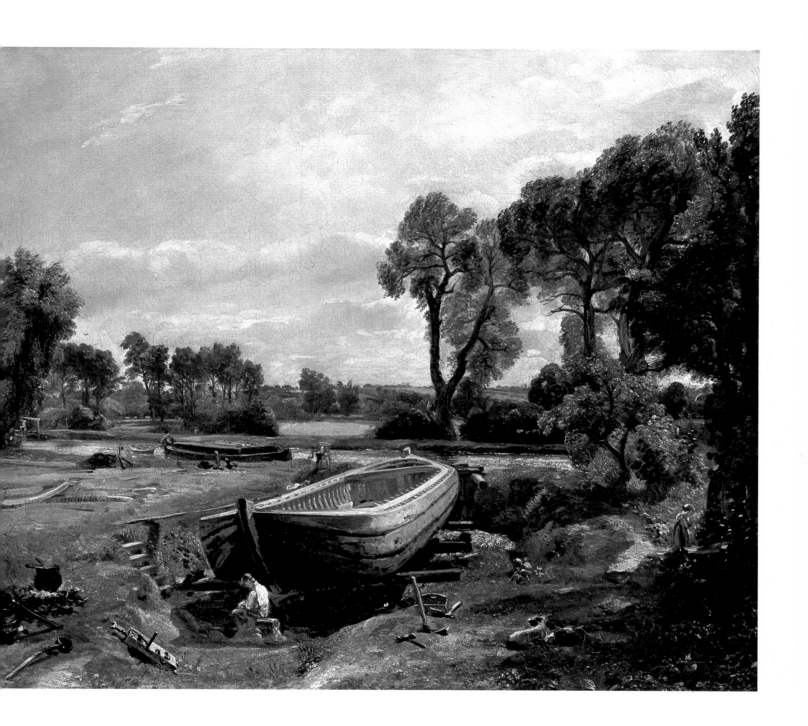

12

Golding Constable's Kitchen Garden

CANVAS, 33 x 51 CM. 1815. IPSWICH BOROUGH COUNCIL MUSEUMS

The view from the back of Constable's father's house at East Bergholt was full of significance for the painter and is a prime example of what meant most for him, a working landscape full of personal human associations. It was this union of personal emotion with landscape, which Constable considered to be God's creation, that is at the centre of his art, the elevation, of the local and personal to the level of universality in art. Constable wrote to Maria Bicknell on 18 September, 1814: ' . . . I can hardly tell you what I feel at the sight from the window where I am writing of the feilds in which we have so often walked. A beautifull calm autumnal setting sun is glowing upon the gardens of the rectory and on adjacent feilds where some of the happiest hours of my life were passed.'

The windmill near Pitts Farm in which he worked as a youth appears in the background of the kitchen garden picture, as does the rectory, which he associated with Maria, the granddaughter of the rector. The local view had an added poignancy for Constable because his mother died in 1815 and his father was to die in the following year, and the settled family life of his youth and early manhood was beginning to change as he reached his fortieth year.

It is now generally agreed that the paintings of Golding Constable's kitchen and flower gardens date from the summer of 1815, for the wheat standing in the field behind the house, according to the 'Norfolk' system of crop rotation, would only have been grown every four years, and 1811 and 1819 can be ruled out for various reasons of style and other evidence. The measured clarity and fastidiousness of the detail, the perfectly judged tone and colour and the careful brushwork all point to this date, and can be compared with the same loving fidelity found in the *Wivenhoe Park* (Fig. 25) of 1816. In paintings such as these Constable achieved perhaps his most completely faithful representation of the facts of nature, with emotion and accuracy blending together. From now on, he became increasingly aware of the need or obligation to present his finished works to the public, and this involved a development of style.

Fig. 25 Wivenhoe Park, Essex

CANVAS, 56. x 101 CM. 1816. WASHINGTON, D.C., NATIONAL GALLERY OF ART (WIDENER COLLECTION)

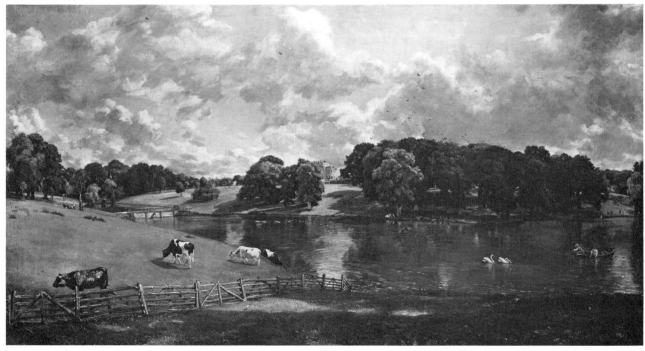

13

Golding Constable's Flower Garden

CANVAS, 33 x 51 CM. 1815. IPSWICH BOROUGH COUNCIL MUSEUMS

This painting is a companion to Plate 12 and the two pictures placed side by side are almost a continuous view from an upstairs window of Golding Constable's house. Although Constable was to become increasingly concerned in his work with 'picture making', the creation of compositions that would express the qualities of nature and his feeling for it, in these two paintings he is a faithful recorder of what he sees and there seems little doubt that he painted at least the major part of them with the view in front of him. By this time he had acquired enough skill to depict accurately the appearances of nature without recourse to consciously borrowing from the techniques and practice of other painters, but his concentration on his subject is so firm and his brushwork is so measured that no style or manner is apparent.

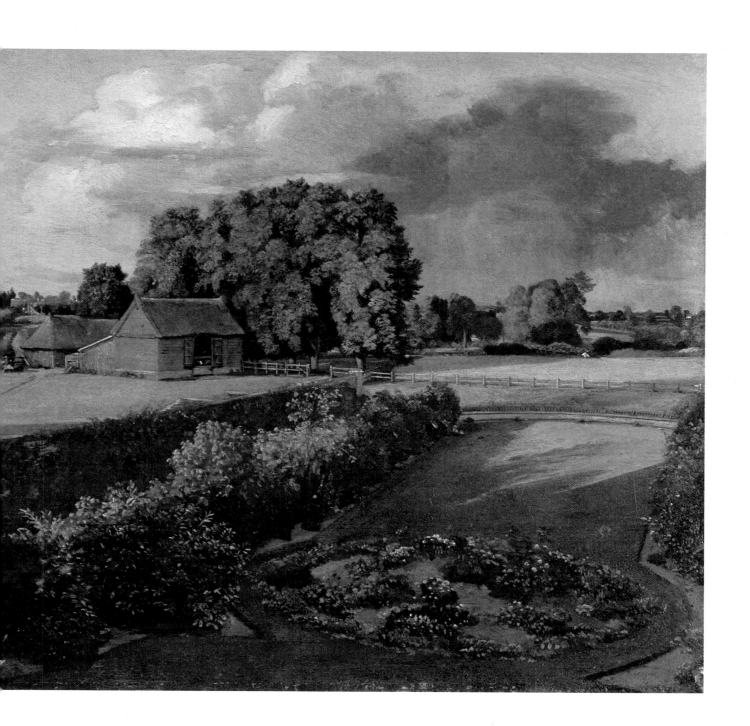

Willy Lott's House

OILS ON PAPER, 24 x 18 CM. C. 1810–16. LONDON, VICTORIA AND
ALBERT MUSEUM

Constable felt for this cottage that kind of emotional, almost obsessive attachment that the landscape and objects local to his youth evoked from him. Willy Lott, the farmer who lived in this cottage all his life, would have been known to Constable. He painted and drew it many times and it appears in the *Mill Stream* (Fig. 26) and the *Valley Farm* (Plate 46) as well as the *Haywain* (Plate 23). It is situated by the mill stream just beyond Flatford Mill, which belonged to Constable's father. Between about 1810 and 1816 Constable made a number of oil sketches including the cottage and had made a finished picture of the *Mill Stream* in 1814. He drew on the oil sketches when painting the *Haywain*, extending the composition further to the right than in this sketch and adding the Haywain itself. This sketch has another oil study of Willy Lott's house on the back, including a horse by the edge of the water. In the full size sketch for the *Haywain* in the Victoria and Albert Museum both the horse and the dog in the illustrated sketch appear, but in the final painting the horse was painted out (see Plate 24, just to the left of the Haywain), though a similar dog does appear. The technique of this oil sketch is typical of Constable's work at this time, with strong tonal contrasts, vigorous tough brushstrokes and the brown ground showing through. Everywhere is apparent a direct uncluttered response to the scene depicted, with emphasis on the shifting quality of light, water and foliage.

Fig. 26 The Mill Stream

CANVAS, 71 x 91.5 CM. C. 1814. IPSWICH, BOROUGH COUNCIL MUSEUMS

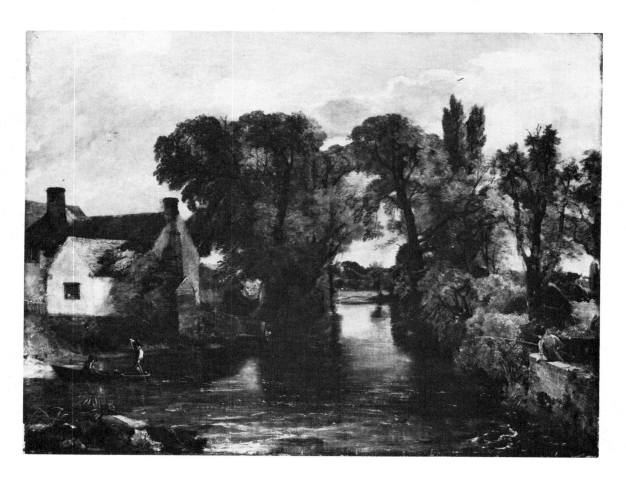

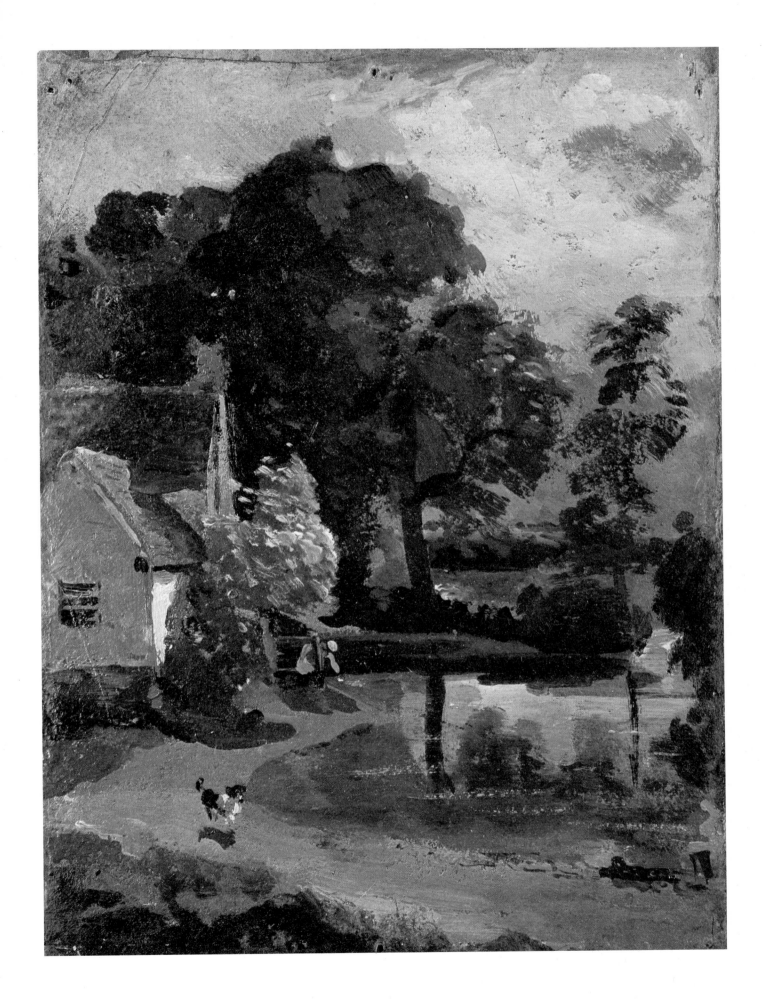

15

Maria Bicknell, Mrs John Constable

CANVAS, 30.5 x 25 CM. 1816. LONDON, TATE GALLERY

Constable painted this portrait, dated 10 July, 1816, a few months before he and Maria were married on 2 October. Their courtship had begun in 1809 and it was prolonged by the opposition to their marriage of Maria's grandfather, Dr. Rhudde, rector of East Bergholt, but in the summer of 1816 they decided to marry, though still against his wishes. Constable mentioned the picture when he wrote to Maria on 16 August: 'I would not be without your portrait for the world the sight of it soon calms my spirit under all trouble and it is always the first thing I see in the morning and the last at night.' Constable was not a successful portrait painter, though he made various attempts at the genre in the early parts of his career, encouraged not by his own inclination so much as the advice of family and friends, who realised that portraiture, rather than landscape, could be a source of income. But in this picture, Constable's love and affection for Maria shines through and the resulting portrait is both tender and full of life.

Fig. 27 Mrs Constable with Two of her Children

OIL ON PANEL, 16.5 x 21.5 CM. EXECUTORS OF LT.-COL. J. H. CONSTABLE

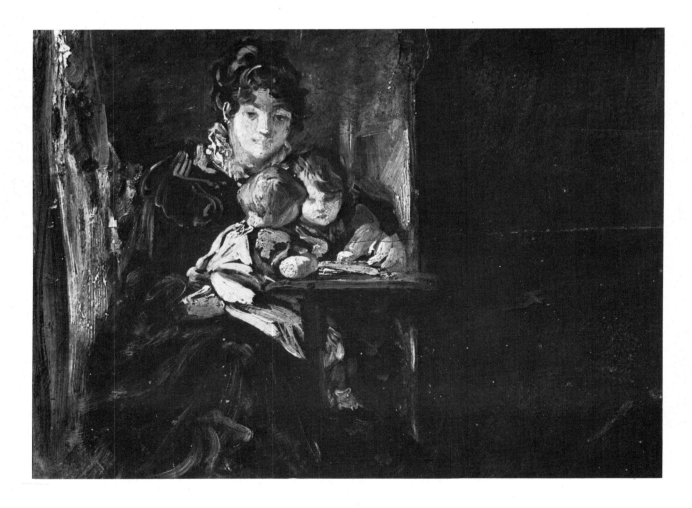

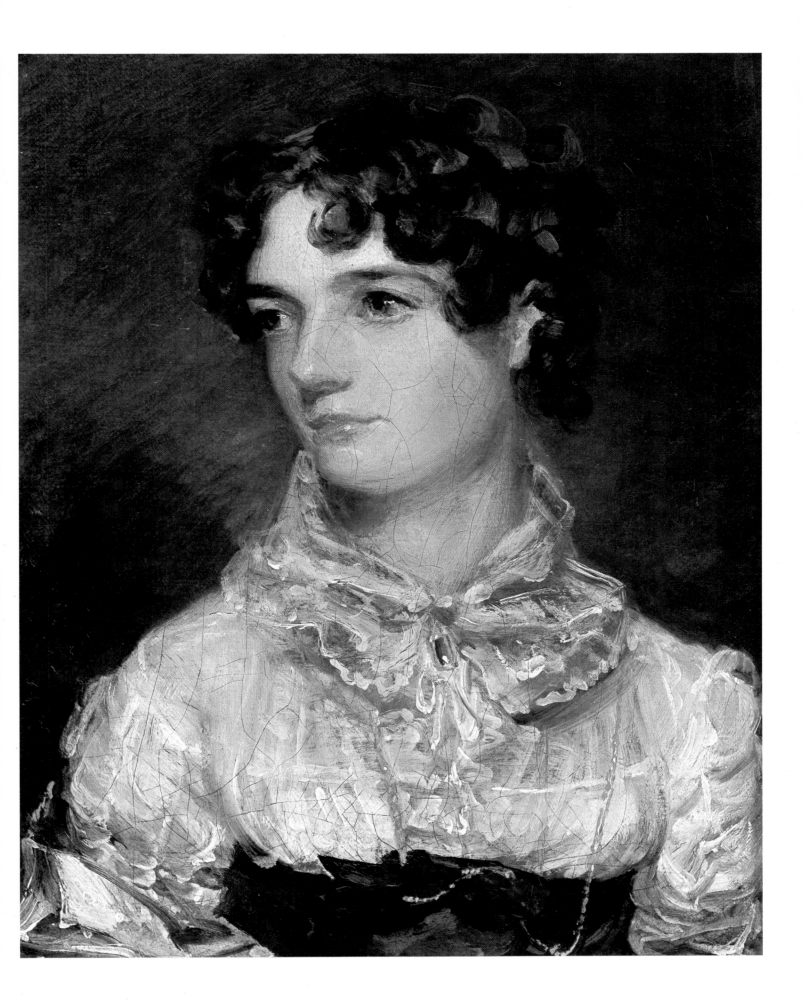

16

Flatford Mill

CANVAS, 102 x 127 CM. 1816/17. LONDON, TATE GALLERY

This was exhibited at the Royal Academy in 1817 as 'Scene on a navigable river'. It represents a further development from the *Boat-Building near Flatford Mill* (Plate 11) towards his larger six foot canvases from the *White Horse* (Plate 21) onwards through the 1820s. It is twice the size of the *Boat Building* and must have been executed in the studio. Constable was probably working on it as early as September 1816, and there are a number of oil sketches that can be related to it as well as some pages in the 1814 sketchbook, including page 63 (Fig. 24), which shows the clump of trees where the river divides in front of Flatford Lock. It is a more complex composition than *Boat-Building* with more movement in the trees, a far stronger sky and a wealth of incidents spread throughout the picture, stretching from the foreground horse being uncoupled from the barges to allow them to be poled under the footbridge, the edge of which appears in the left foreground, to the figure of the man with the scythe on the far right middle distance. These incidents express Constable's desire to show the working life of the Stour valley, a landscape full of 'human associations', and the location is again Flatford, with his late father's mill in the background. Constable's problem was to represent minutely all these details of people, trees, river and water plants with loving accuracy and at the same time to capture the broader play of light and shade of a summer's day, what he called the 'chiaroscuro' of nature. After the exhibition, Constable seems to have repainted parts of the main group of trees on the right, where there are *pentimenti*, and there is a careful drawing of the two trees, made on 17 October 1817, well after the exhibition, which corresponds very closely to the painting as it now is. Such alterations to finished paintings were not uncommon in Constable's practice.

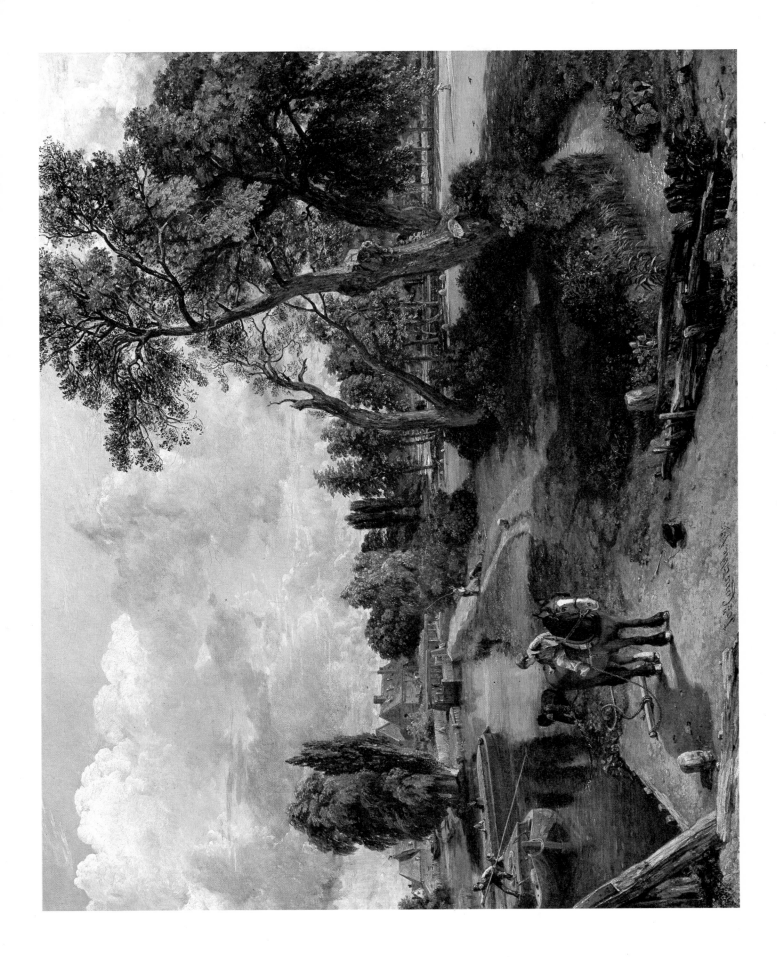

Detail from 'Flatford Mill' (Plate 16)

The two foreground trees in this detail are those which appear in the right background of *Boat-Building near Flatford Mill* (Plate 11), and in the intervening period of three years since *Boat-Building* was painted the farther one seems to have lost much of its upper foliage, unless Constable had decided in the earlier painting to restore the damaged tree for compositional reasons. The line of trees in the distance can also be seen in the left background of *Boat-Building*. The foreground trees appear in a page from a sketchbook which Constable used in the summer of 1813 (Fig. 28). This sketch also includes the bridge and Flatford Mill in the background. Constable wrote in March 1814 to Maria Bicknell, about this sketchbook: 'You once talked to me about a journal. I have a little one that I made last summer that might amuse you could you see it – you will then see how I amused my leisure walks, picking up little scraps of trees, plants, ferns, distances, &c. &c. .'

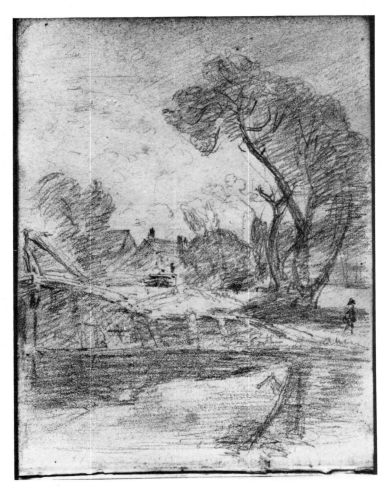

Fig. 28 Flatford Mill

PENCIL ON PAPER, 9 x 12 CM. 1813 SKETCHBOOK, P. 10. LONDON, VICTORIA AND ALBERT MUSEUM

Detail from 'Flatford Mill' (Plate 16)

Originally Constable painted a horse on the tow-path in the middle distance where the reclining boy can now be seen. This horse can be seen in an X-ray of the painting (Fig. 29). Constable painted it out, but the naked eye can still pick up the shape of the horse in the finished painting, and the towing harness has been left in on the grass. The horse with a boy on his back in the finished painting has been given a more prominent position, and one which successfully joins the two halves of the composition and provides a more satisfactory focus for the foreground, also strengthening the sense of recession in the picture towards the lock and Flatford Mill in the background. This detail also clearly shows the river dividing, with to the left the stream leading to Flatford Mill and to the right the main stream going into Flatford Lock.

Fig. 29 X-ray of detail from 'Flatford Mill'

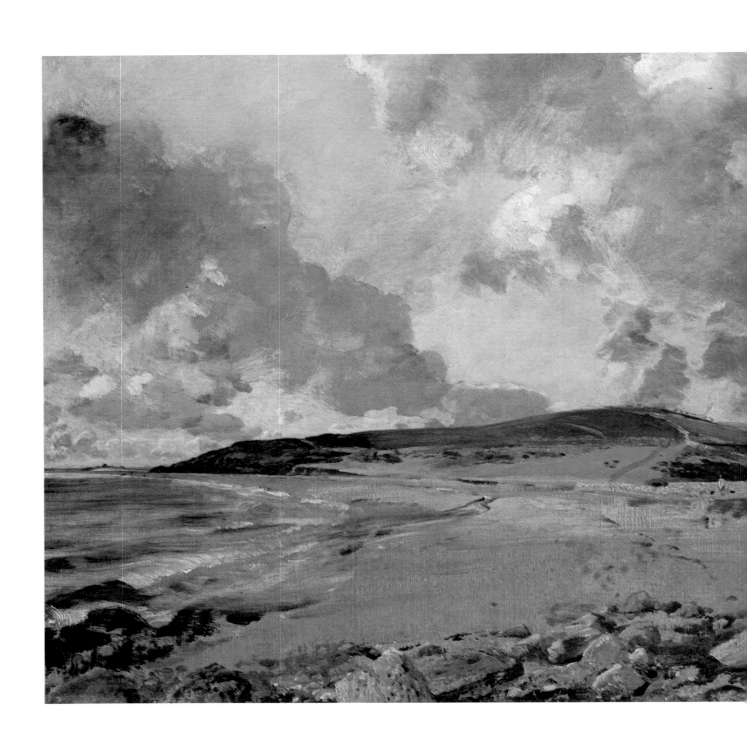

Weymouth Bay

CANVAS, 51 x 75 CM. 1816–17 OR LATER. LONDON, NATIONAL GALLERY

Constable married Maria Bicknell on 2 October 1816, and they spent most of their honeymoon with the Fishers, also recently married, at Osmington. Here Constable painted a number of studies of the Dorset coast, including a view of Weymouth Bay, in oils on millboard, which is in the Victoria and Albert Museum. At some later date he produced two more finished versions of the same composition, one of which is in the Louvre, the other being the illustrated painting. The Louvre version (Fig. 30) is now regarded as the one from which Lucas engraved the mezzotint 'Weymouth Bay, Dorsetshire', which appeared in Constable's *English Landscape Scenery*. The National Gallery picture has a tonally powerful sweep of clouds, scudding over the coast, and the brown ground has been used extensively to stand for the beach, parts of the sea and clouds.

Fig. 30 Osmington Shore, near Weymouth

CANVAS, 88 x 103 CM. AFTER 1816. PARIS, LOUVRE

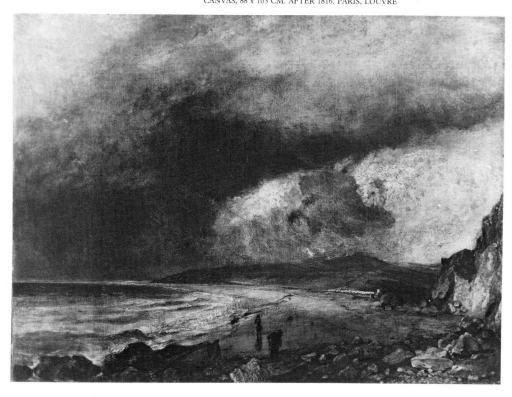

Waterloo Bridge from Whitehall Stairs

OILS ON MILLBOARD, 29 x 48 CM. C.1819? LONDON, VICTORIA AND ALBERT MUSEUM

Constable could have witnessed the opening of Waterloo Bridge by the Prince Regent on 18 June, 1817. In 1819 he made his first sketch of the subject, but despite his probable intention to exhibit a large painting of the event at the Royal Academy in 1821 and his frequent subsequent workings at the subject, he did not exhibit a picture, now in a private collection, at the Royal Academy until 1832 (Fig. 31) The illustrated oil sketch, which has an oil study of a woodland scene on the back, has been associated with the painting that he showed to Farington on 11 August, 1819. Farington wrote, 'I objected to his having made it so much a "Birds eye view" and thereby lessening magnificence of the bridge & buildings. – He sd. he would reconsider his sketch.' It is open to doubt whether the Victoria and Albert Museum oil sketch is the one that Farington mentions, but the style and technique are compatible with the proposed date.

Fig. 31 Whitehall Stairs, June 18th, 1817.
The Opening of Waterloo Bridge

CANVAS, 134.5 x 219.5 CM. 1832. PRIVATE COLLECTION

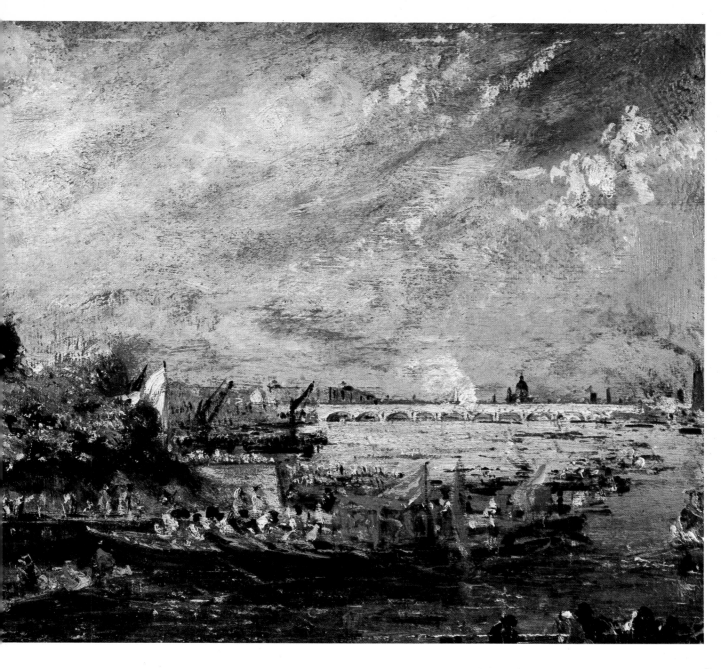

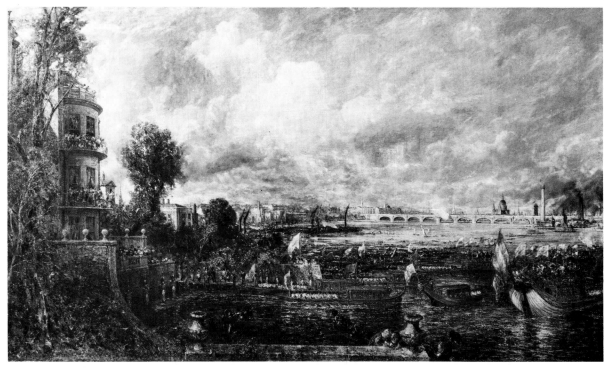

The White Horse

CANVAS, 131 x 188 CM. 1819. NEW YORK, FRICK COLLECTION

In 1819 Constable exhibited his first large canvas at the Royal Academy, a 'six-footer', that is about four feet high and six feet long. It was entitled 'A scene on the river Stour', but John Fisher, who bought the painting for 100 guineas, called it 'The White Horse'. It was generally well received, and the critic in the *Examiner* said that it 'is indeed more approaching to the outward lineament and look of trees, water, boats, etc. than any of our landscape painters.' Leslie said that it 'attracted more attention than anything he had before exhibited', and this may have been due in part to its size. Constable seems to have realised that if he was going to have his paintings seen as belonging to the great tradition of European landscape, they would have to be somewhat monumental in size, if only so that they would stand out amid the hundreds of works exhibited at Somerset House at the Royal Academy exhibitions. There is some doubt as to whether Constable painted a full size study for this picture, as he was later to do with the *Haywain* and most of his large paintings of the 1820s. A picture in the National Gallery of Art, Washington, D.C., has been claimed as the study for *The White Horse*, but there remains a lot of doubt as to whether it is a fully autograph work. The view represented seems to be just downstream from Flatford Mill, showing, by the thatched boat-house, the mill stream rejoining the main river.

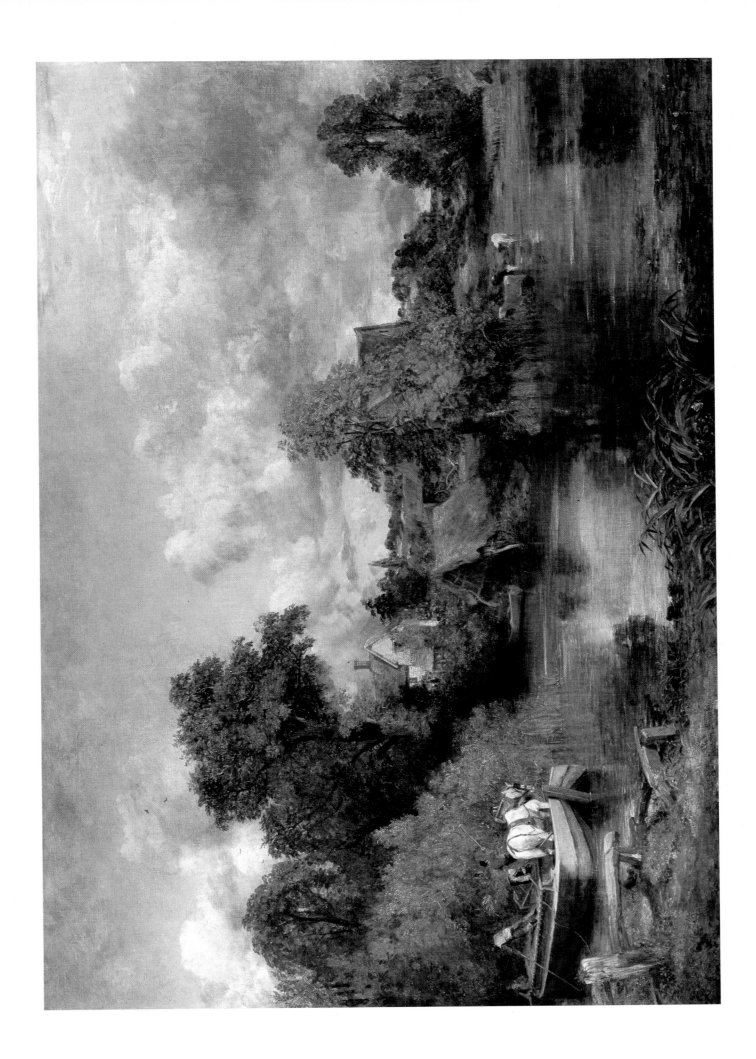

Hampstead Heath

CANVAS, 54 x 77 CM. C.1820. CAMBRIDGE, FITZWILLIAM MUSEUM

Constable first took a house at Hampstead in 1819. From then on he regularly spent some months there most years, and often his family stayed in Hampstead while he was in his studio at Charlotte Street. This painting was among the first finished pictures that he made of Hampstead Heath and it may possibly have been exhibited at the Royal Academy in 1821 or 1822, though there is no way of being sure about this. It is a pair to a painting in the Victoria and Albert Museum, which shows a view looking in roughly the opposite direction over the Vale of Health pond towards Highgate and the East. The illustrated painting shows the view towards Harrow looking from a point near Whitestone Pond, with Branch Hill Pond being out of sight to the left. Leslie, commenting on a similar picture of the Heath, now in the Tate Gallery, used it as an example of how warm colours were not necessary to produce the impression of warmth in a landscape, and he mentioned the blue sky, the deep blue distance and the fresh green of the grass, cool colours that are all evident in the illustrated work. Leslie also remarked on how these cool colours are balanced by the red coat of a labourer, and again in this painting the same red accent is found. It was a device that Constable used regularly, often, as in this picture, also on the harness of the horses. In a sketchbook in the British Museum, used in 1819, Constable drew many sketches of subjects he found on Hampstead Heath such as carts, workmen and donkeys. These all reappear frequently in his subsequent paintings of Hampstead Heath. In this picture the workmen appear to be engaged in dumping, in the foreground, and possibly in excavating, in the background, material from the ground. Sand and gravel were taken from the Heath, and also its water was being blocked, drained and dammed both to make good the land and to provide for London's water supply.

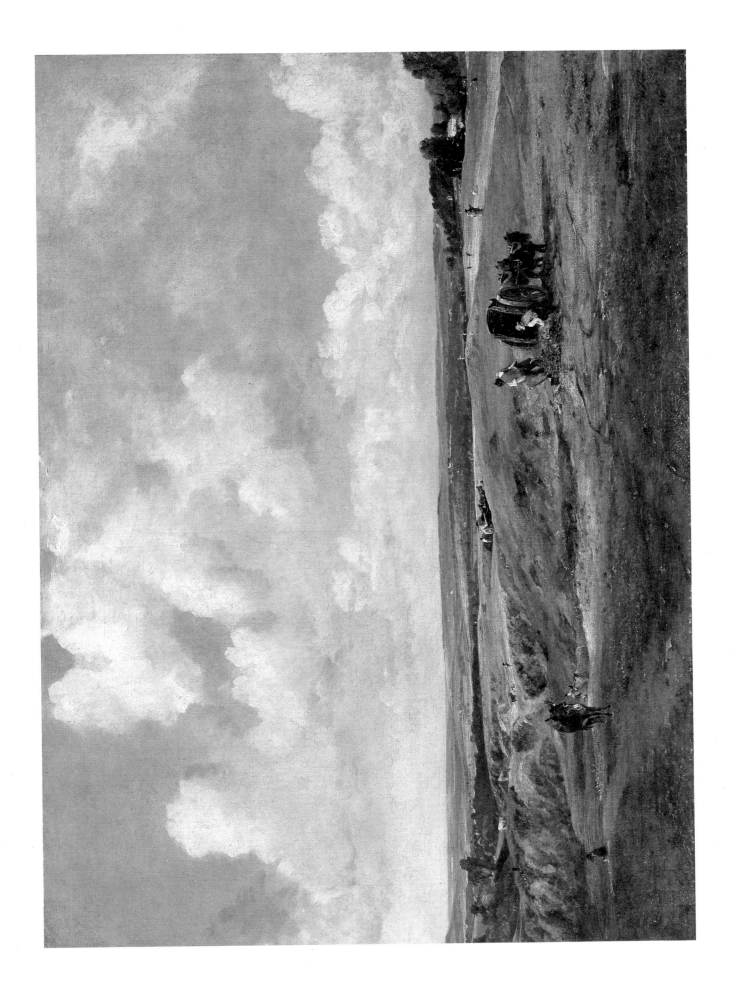

The Haywain

CANVAS, 130.5 x 185.5 CM. 1821. LONDON, NATIONAL GALLERY

The Haywain, Constable's most famous painting, was exhibited at the Royal Academy in 1821. In the previous year he had exhibited *Stratford Mill* (Fig. 2), another Stour scene, and it seems that for the 1821 exhibition he had originally intended to exhibit a picture of the opening of Waterloo bridge (see Fig. 31 and Plate 20), but it was not until 1832 that this subject was exhibited. Farington advised him to choose a subject similar to *Stratford Mill* because it had been successful and Constable seems to have followed his advice. *The Haywain*, or 'Landscape: Noon' as it was entitled, shows a very similar view to the *Mill Stream* (Fig. 26) of 1814, but the angle has been changed, the stream broadened out and the distant fields on the right have been included as a counterpoint to the group of cottage and trees on the left. The resulting strong horizontal emphasis has given to the composition a sense of peace and repose appropriate to the middle of a summer day. The importance to Constable of Willy Lott's cottage which appears on the left, and his oil sketches of it made between about 1810 and 1816, have been discussed in the notes to Plate 14. As well as these studies, Constable made for the *Haywain* a full size sketch, now in the Victoria and Albert Museum, possibly the first time that he made use of such an aid in producing one of his large pictures. The sketch is thinly painted, the ground showing through a great deal, and it seems that Constable used the sketch to work out the main lines of the composition and to get a broad idea of the fall of light and shade and the balance of the masses. The painting of a full size sketch was extremely rare, if not unique, as a method of working and it must have been both expensive on materials and time consuming. Constable produced *The Haywain* in the winter months of 1820/1 for the Royal Academy exhibition in May and it was painted in his studio in London, far away from the scenery it depicted. He got John Dunthorne to draw for him a Suffolk harvest waggon, which Constable's brother, Abram, sent to him in London, writing, on 25 February 1821, 'I hope it will answer the desired end; he [Dunthorne] had a very cold job.' Given this method of composition, it is amazing that Constable was able to inject into his painting so much of the look and feel of nature.

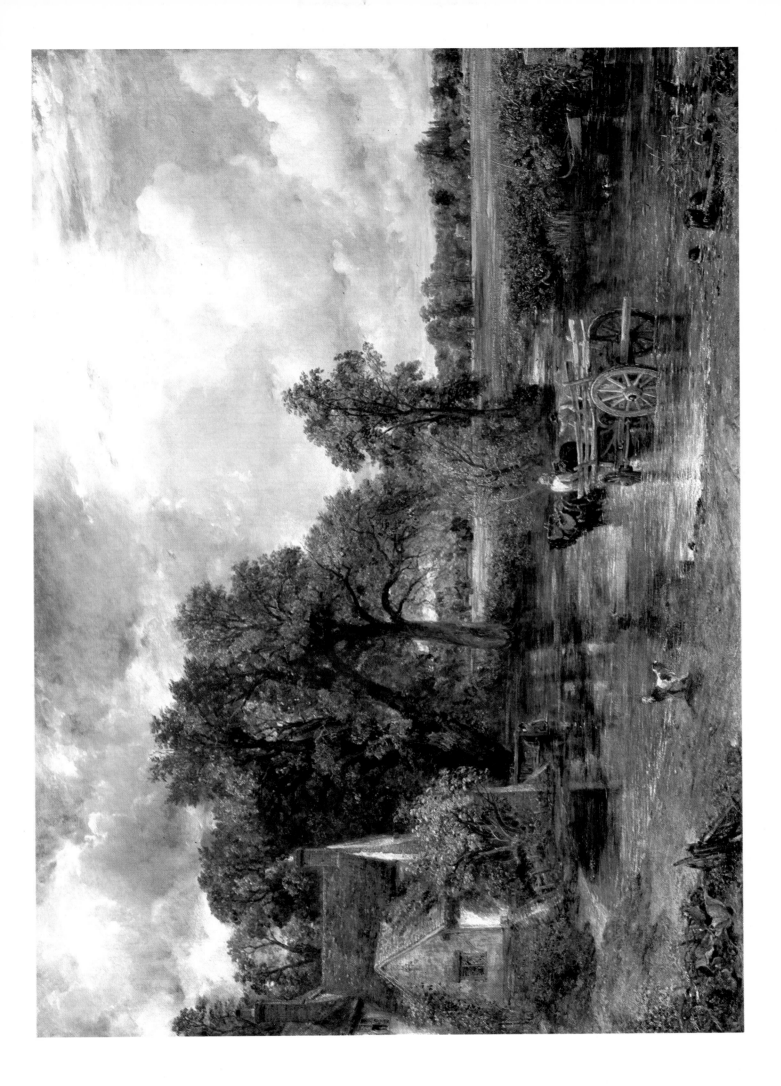

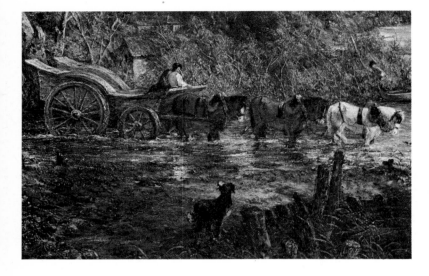

Detail from 'The Haywain' (Plate 23)

Constable captures the tranquillity of a summer day at noon. His habit of putting red on the harness of horses towing carts or barges was commented on by Leslie, in connection with *The Leaping Horse*, as if it was a record of actual appearances. David Lucas, the engraver, on the other hand, recorded an occasion when Constable was criticized by his father's barge man for his inaccuracy in putting such 'housings' on a towing horse. Constable replied that it gave him the opportunity of 'introducing the bright red colour of the fringe as a contrasting one in opposition to the greens'. The details on this page show that Constable often introduced a note of bright red into his scenes, either on the harness of a horse or on a man's jacket, and it seems clear that his reasons for doing so were largely pictorial.

Fig. 32 Detail from 'Salisbury Cathedral from the Meadows' (Plate 44)

Fig. 33 Detail from 'Hampstead Heath' (Plate 42)

Fig. 34 Detail from 'The White Horse' (Plate 21)

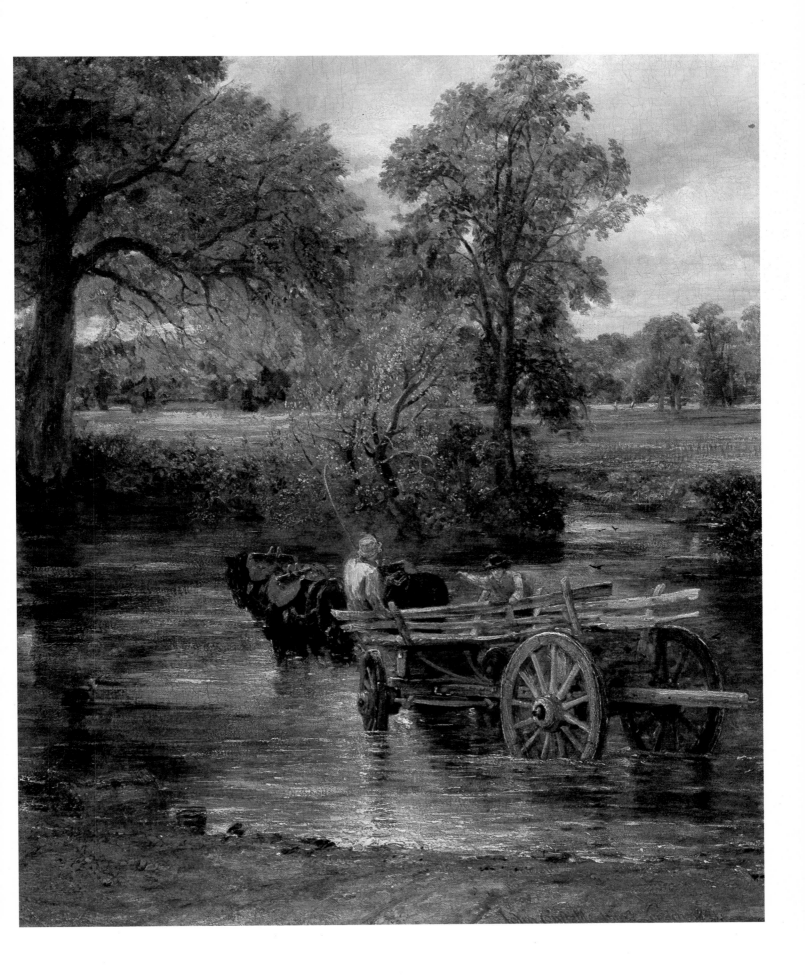

Study of Hampstead Heath, looking West

OILS ON PAPER ON CANVAS, 25.5 x 30 CM. 14 JULY 1821. LONDON, ROYAL ACADEMY OF ARTS

One of the many oil studies that Constable made on the high points of Hampstead Heath in the early 1820s. This looks west, as the sun is sinking, with the spire of Harrow church at the far left. These sketches show a preoccupation with the sky, an interest further developed in the sky and cloud studies done at this time, many on the Heath itself, such as Plate 26. Constable's interest in weather effects and times of day, the immediate and the particular, is shown by the inscription on the stretcher of this study, 'Hampstead July 14 1821 6 to 7 pm N.W. breeze strong'. It also gives an idea of the speed at which he had to work to capture these effects before the cloud pattern changed.

Fig. 35 also shows the speed with which his Hampstead sketches in 1821 were made, notably in the flicked in highlights of the foliage.

Fig. 35 Study of Sky and Trees, Hampstead

OIL ON PAPER, 24.5 x 30 CM. 1821. LONDON, VICTORIA AND ALBERT MUSEUM

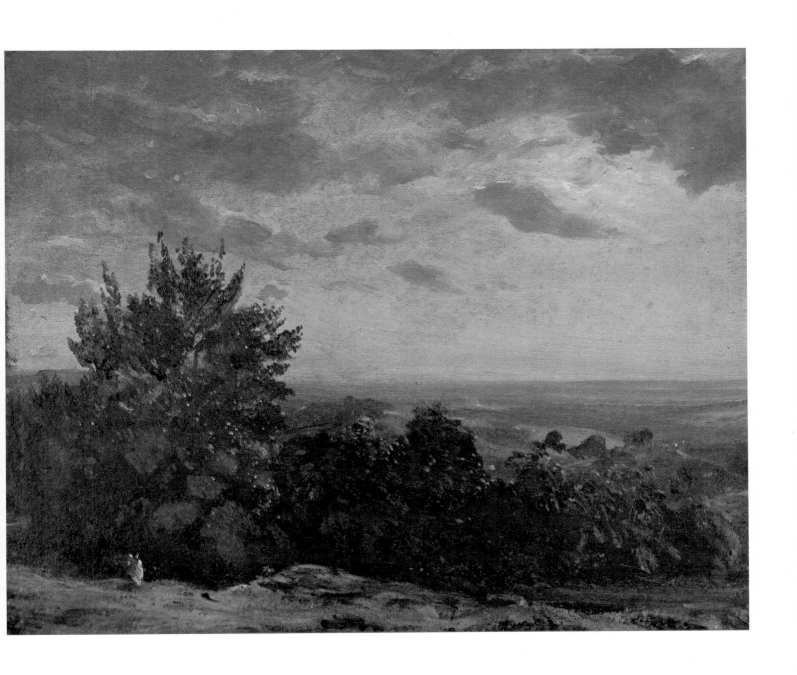

Cloud Study with an Horizon of Trees

OILS ON PAPER ON PANEL, 25 x 29 CM. 27 SEPTEMBER 1821. LONDON, ROYAL ACADEMY OF ARTS

Fig. 36 Study of Sky and Trees with a Red House, at Hampstead

OIL ON PAPER, 24 x 30 CM. 1821. LONDON, VICTORIA AND ALBERT MUSEUM

This cloud study is inscribed on the back, 'Noon 27 sept very bright after rain wind West'. (See notes to Plate 30.) Fig. 36 is another tree and cloud study which Constable painted in September 1821.

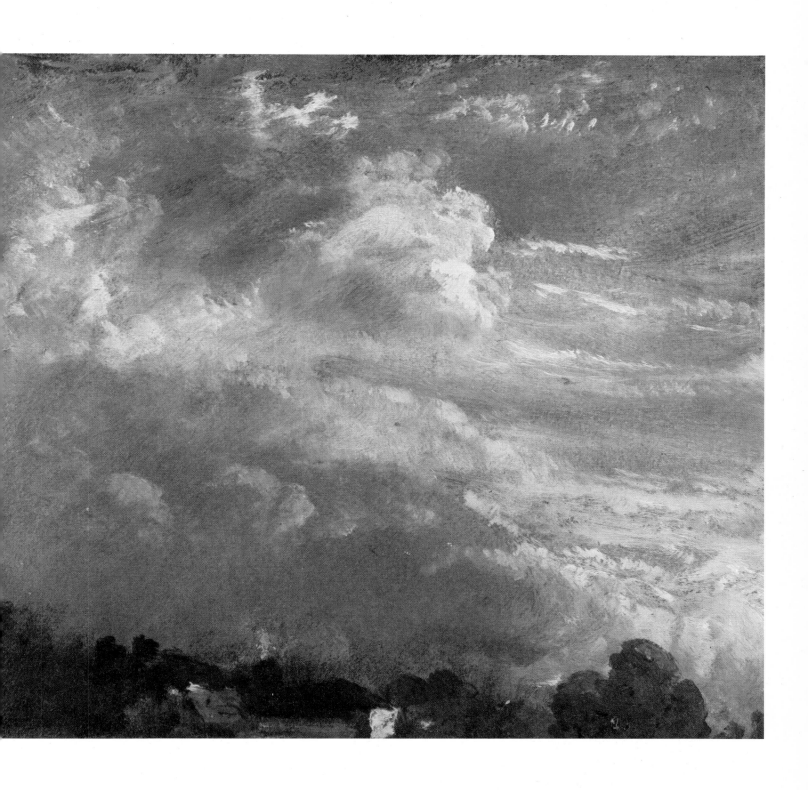

Buildings on Rising Ground near Hampstead

OILS ON PAPER, 25 x 30 CM. 13 OCTOBER 1821. LONDON, VICTORIA AND ALBERT MUSEUM

As with Plate 29 the time of day and weather effects are carefully noted on the back, 'Octr – 13th. 1821. – 4 to 5 afternoon – very fine with Gentle Wind at N.E.' The house may be the one known as the 'Salt Box' and the water may be Branch Hill Pond. In this year Constable had taken the house at No. 2 Lower Terrace, Hampstead. The watercolour (Fig. 37) of *The Lower Pond, Hampstead*, dated 26 June, 1823, seems to be based on a small pencil sketch made in the 1819 sketchbook now in the British Museum. It has the slightly decorative and colourful effect associated with his watercolours of the second half of his career.

Fig. 37 The Lower Pond, Hampstead

PENCIL AND WATERCOLOUR, 17 x 25.5 CM. 1823. LONDON, BRITISH MUSEUM

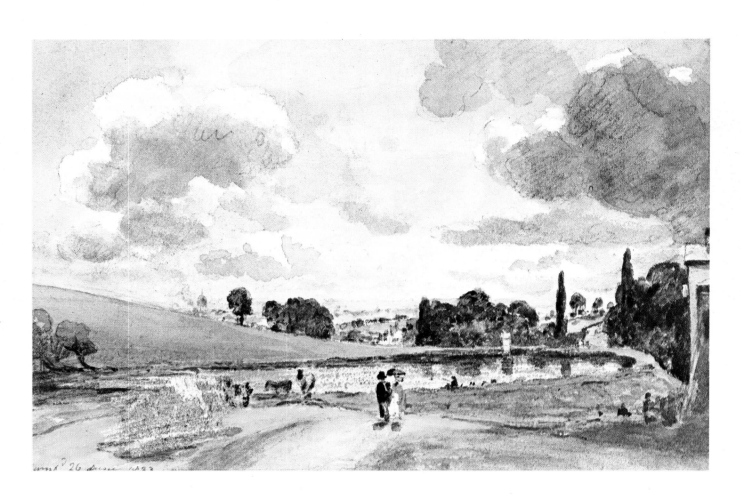

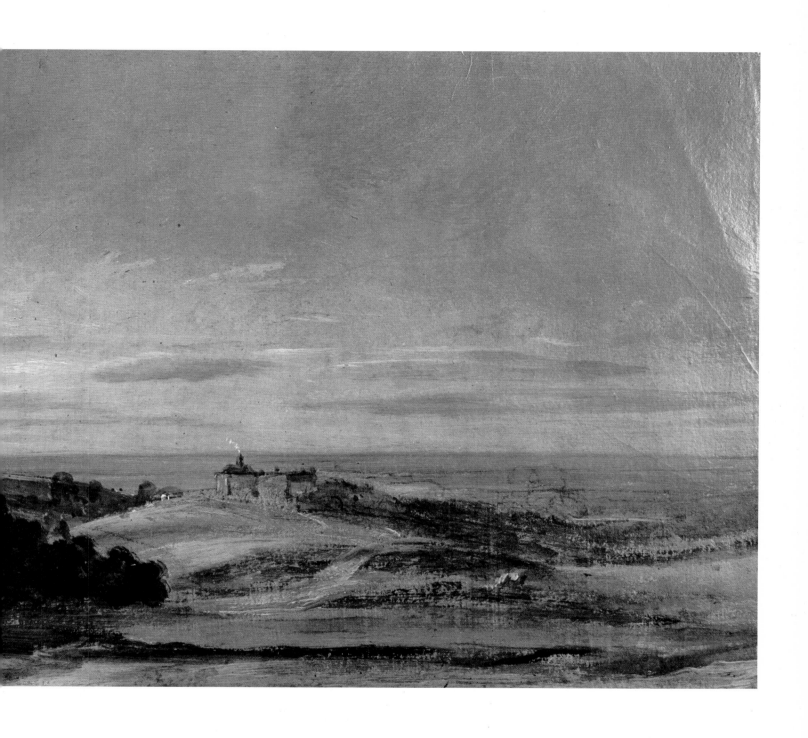

Salisbury: The Close Wall

CANVAS, 60 x 51 CM. 1821? CAMBRIDGE, FITZWILLIAM MUSEUM

This is a good example of Constable's care, even in a relatively unfinished painting, to depict the many greens in landscape and to express the variety of grass, foliage and waterplants accurately and to distinguish their various shapes and forms.

His ability to express accurately the varying shapes and forms of nature is also found in his careful pencil drawings, such as that of Salisbury Cathedral seen from over the river, dated 20 August 1823 (Fig. 38).

Fig. 38 Salisbury Cathedral Seen from the River

PENCIL ON PAPER, 18 x 26 CM. 1823. LONDON, VICTORIA AND ALBERT MUSEUM

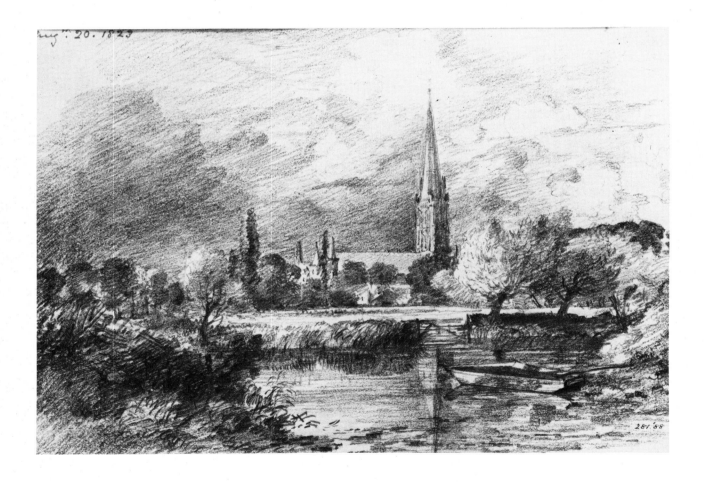

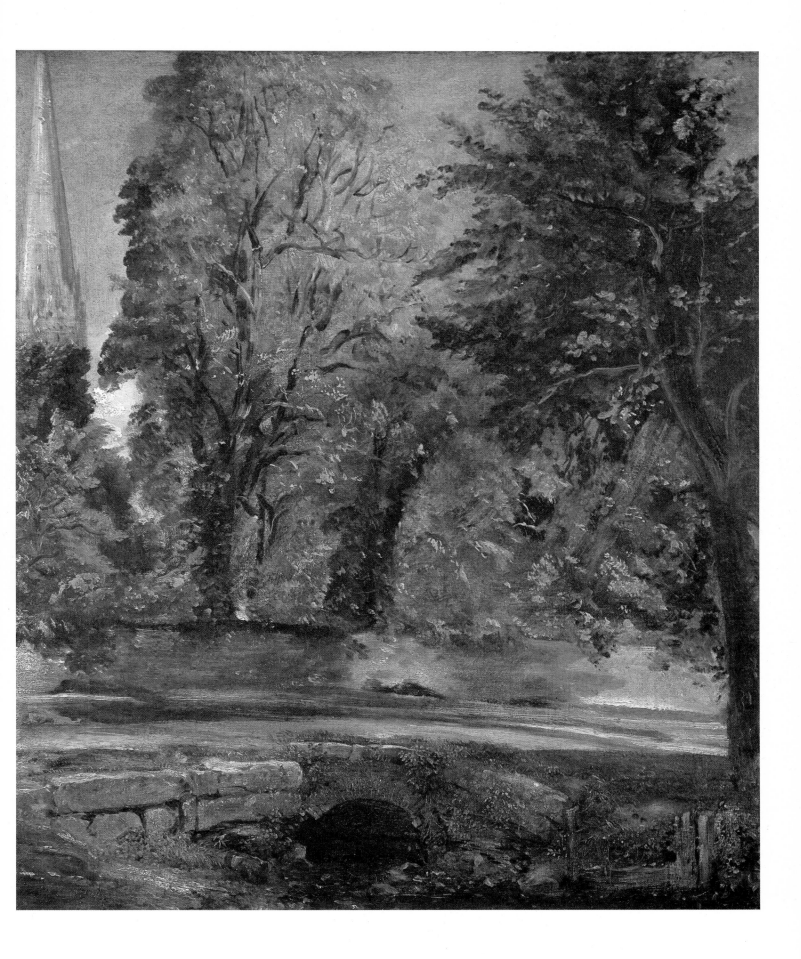

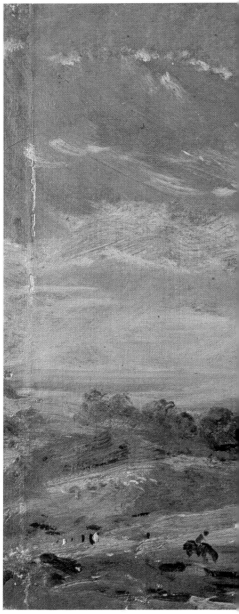

Branch Hill Pond, Hampstead

CANVAS, 24 x 39 CM. C.1821–2. LONDON, VICTORIA AND ALBERT MUSEUM

Another view on Hampstead Heath, probably of Branch Hill Pond, looking in the general direction of Harrow. The edge of the canvas at the bottom and both sides has been painted later to enlarge the composition, presumably after it had been taken off its original stretcher. The figure of a mounted horse, drinking at the edge of the water, regularly appears in Constable's work, as in Plate 33 and Plate 42. A drinking horse had also appeared in the full size sketch for the *Haywain*, of 1821, but it was painted out in the finished picture.

Another slightly earlier oil sketch of Branch Hill Pond (Fig. 39), dated 1819, was used by Constable as the basis for a number of finished paintings (see Plate 42).

Fig. 39 Branch Hill Pond

CANVAS, 25.5 x 30 CM. 1819. LONDON, VICTORIA AND ALBERT MUSEUM

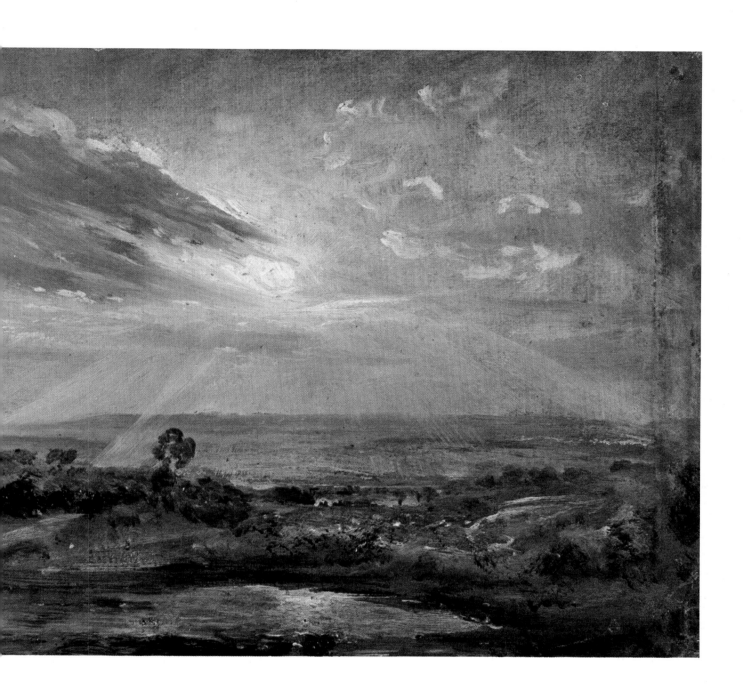

Cloud Study

CANVAS, 48 x 57 CM. C.1822. LONDON, TATE GALLERY

Constable painted a large number of sky studies at Hampstead in 1821 and 1822 and though there are some of later date he made a special study of the sky in these two years. The 1821 sketches tend to have land or trees along the bottom (see Plate 26) while those in 1822 are mainly of the sky alone. On 7 October, 1822, Constable wrote to Fisher that he had painted 'about 50 carefull studies of *skies* tolerably large', and perhaps the illustrated painting is one of them as it is somewhat bigger in size and more finished than his usual oil sketches. Constable wrote a long letter to Fisher on 23 October 1821, in which he explained his interest in the sky. 'The sky is the "source of light" in nature – and governs everything. Even our common observations on the weather of every day, are suggested by them but it does not occur to us.' More of this letter is quoted on pp. 14–15 of the text. The notes on weather conditions and times of day which Constable wrote on the back of these sky studies and also his other sketches show his interest in the changing weather patterns and how succeeding conditions were affected by earlier ones, for example how sunlight looked after a period of rain, how wind from a certain quarter would affect later weather, and so on. Constable does not seem to have used his sky studies as exact models for particular finished pictures – they tend to show only part of the sky for one thing – but he clearly considered them of great importance both for use as a helpful reference when painting in the studio and as part of that active natural observation that he saw as a kind of scientific study, pursued almost as an end in itself. But the general character of the skies Constable observed above Hampstead could be included in his finished paintings, even those of the Stour valley and places other than Hampstead. It is arguable, for example, that the sky of the *Haywain* (Plate 23) is a 'Hampstead' sky, although it was painted just before he began his concentrated sky studies. Constable also sometimes used the same sky in different paintings. The sky in the *Harwich Light-house* (Fig. 40) of 1820, in the Tate Gallery, is very similar to the sky in the *Yarmouth Jetty* of 1823 in the Tate Gallery, and there are several versions of both compositions.

Fig. 40 Harwich Light-House

CANVAS, 32.5 x 50 CM. EXHIBITED 1820? LONDON, TATE GALLERY

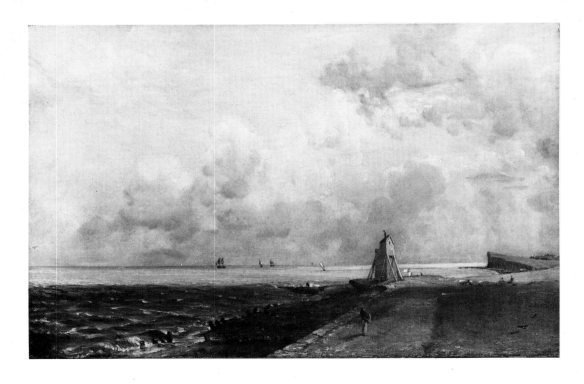

Study of a House amid Trees: Evening

OILS ON PAPER, 25 x 30.5 CM. 4 OCTOBER 1823. LONDON, VICTORIA
AND ALBERT MUSEUM

The exact location of this oil sketch has not been identified,
but it seems to have been done at Hampstead because in
1823 Constable was in London from 10 September, when
he returned from a stay with Fisher at Salisbury, until
about 20 October, when he went to visit Sir George Beau-
mont at Coleorton. In London he alternated between his
house at Charlotte Street, where he had his studio, and
Hampstead, where his wife and family tended to stay. At
Coleorton, Constable spent much of his time copying two
Claude landscapes belonging to Beaumont, refreshing his
mind with the art of the past, though his wife, in London,
grew increasingly irritated by his prolonged absence.

Constable loved trees and was always careful to depict
the differing shapes and varying foliage of the different
species, as can be seen in Figure 41.

Fig. 41 Trees at Hampstead

OIL ON CANVAS, 91.5 x 72.5 CM. 1821? LONDON, VICTORIA AND ALBERT
MUSEUM

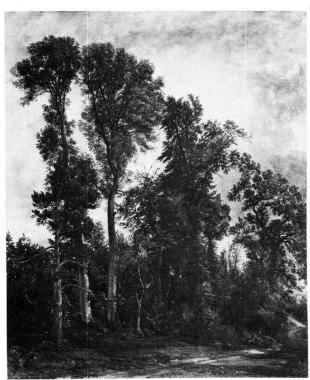

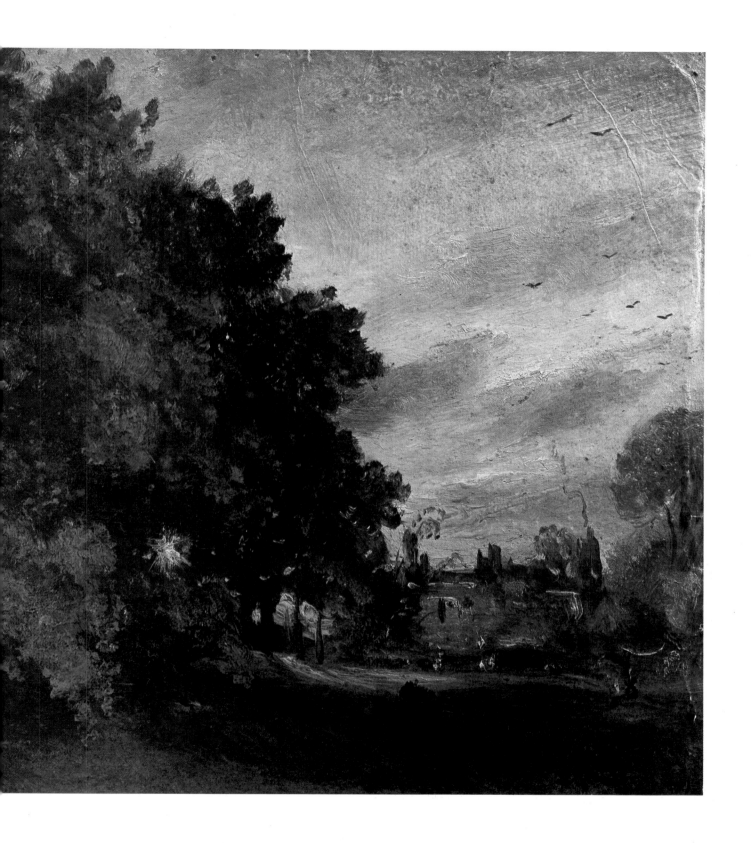

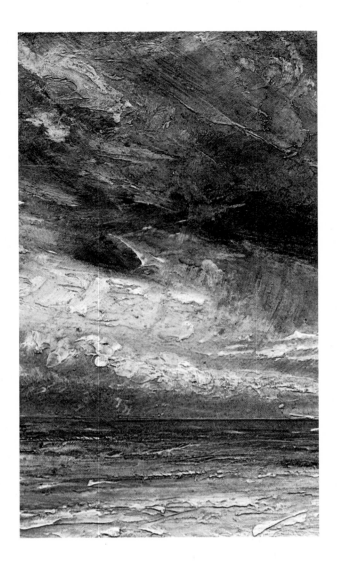
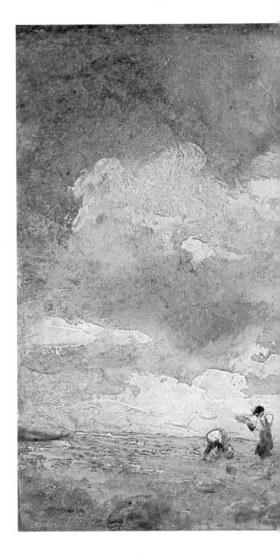

Fig. 42 Detail from 'Coast at Brighton, Stormy Day'

OIL ON CANVAS, INSCRIBED 'BRIGHTON, SUNDAY EVENING, JULY 20, 1828'.
NEW HAVEN, CONNECTICUT, YALE CENTER FOR BRITISH ART (PAUL
MELLON COLLECTION)

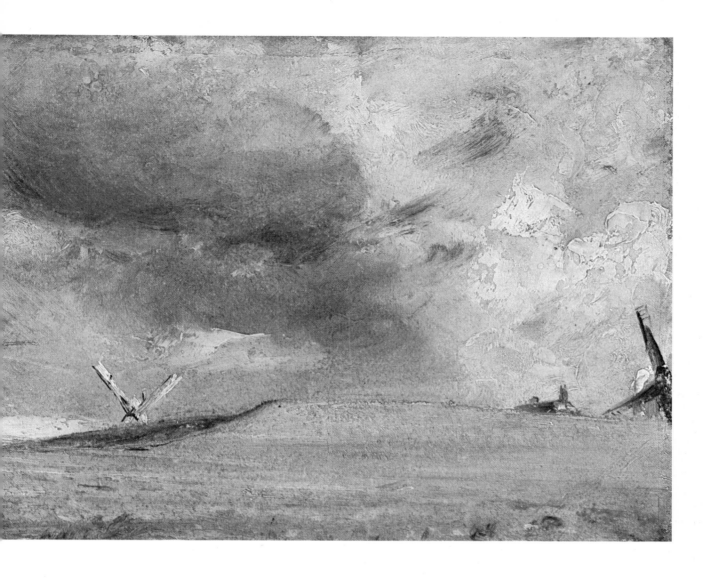

The Gleaners, Brighton

CANVAS, 16 x 30 CM. 1824. LONDON, TATE GALLERY

This is a very free sketch, which captures the feel of the wind and the sense of downland light and space in the hills above Brighton. Constable's use of the palette knife is evident in the highlights of the clouds. He sent a group of his oil sketches to John Fisher in January, 1825, saying '. . . they were done in the lid of my box on my knees as usual.' *The Coast at Brighton, Stormy Day* (Fig.42) also shows the use of the palette knife, and was painted on the evening of Sunday, 20 July 1828.

The Grove, Hampstead
(The Admiral's House)

CANVAS, 36 x 30 CM. C.1820–5. LONDON, TATE GALLERY

Probably painted in the early 1820s, the picture is rather similar in technique to the view of *Salisbury Cathedral* (Plate 35), though somewhat darker in tone. The house framed by trees is known as 'The Admiral's House', which was built for Admiral Matthew Barton, who apparently arranged the roof like the quarter deck of a man-of-war. Another view of the same house appears in Figure 43, probably datable to the same time. The view of the Victoria and Albert Museum painting is taken from an upper window of 2, Lower Terrace, Hampstead, which was rented by Constable in 1821 and 1822.

Fig. 43 The Grove, Hampstead

OIL ON PAPER, LAID ON CANVAS, 24.5 x 29 CM. 1821–2. LONDON, VICTORIA AND ALBERT MUSEUM

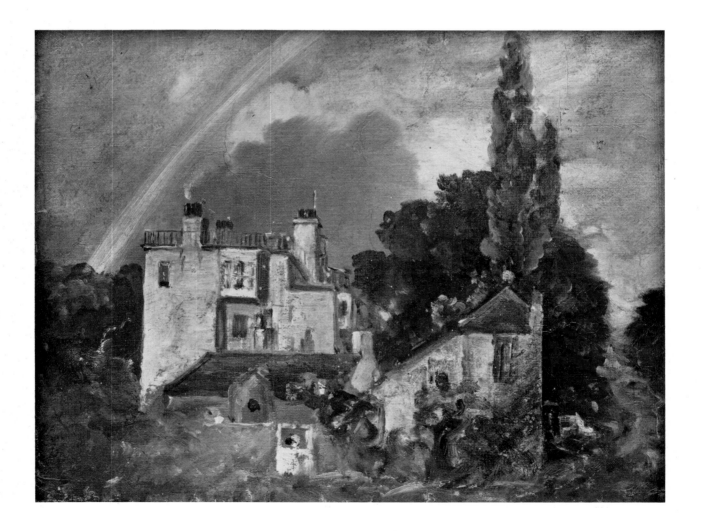

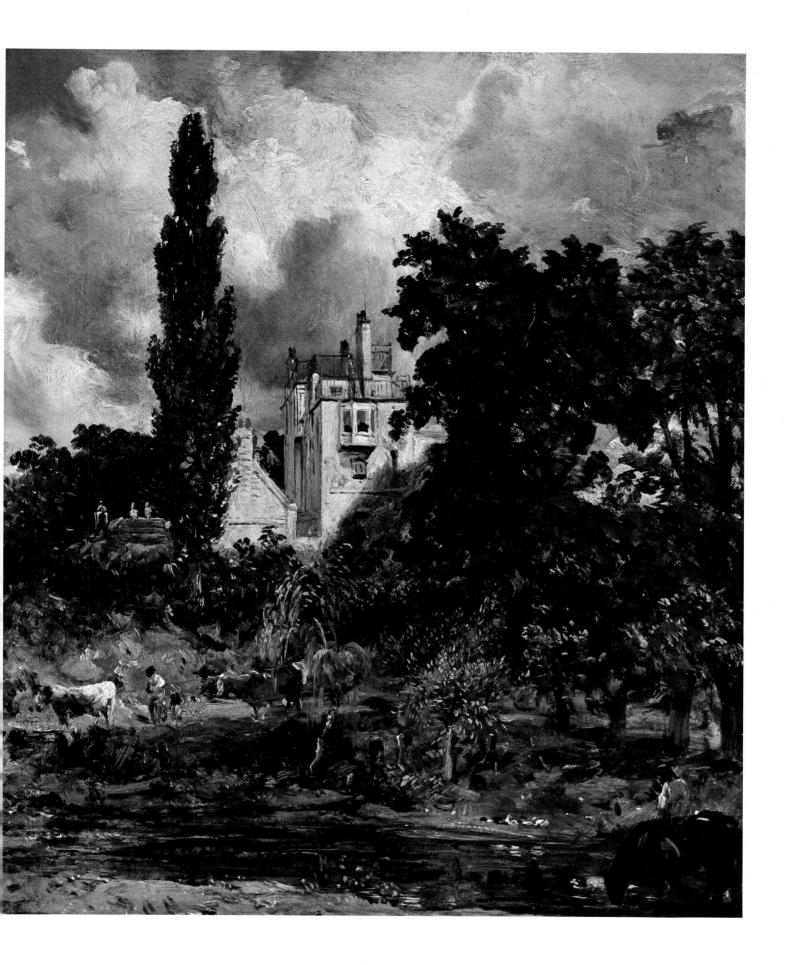

Seascape Study with Rain Clouds (near Brighton?)

OILS ON PAPER ON CANVAS, 22 x 31 CM. C.1824-5. LONDON, ROYAL ACADEMY OF ARTS

Constable first took his wife to Brighton in 1824 for her health and this oil sketch was probably done on his first, or one of his subsequent visits. It captures the fleeting effect of a rain storm at sea with a shaft of sunlight breaking through on the left to light up the horizon. Constable's cloud studies are discussed in the text, pp.21–2, and in the note to Plate 30. Dramatic cloud effects and the threatening effects of stormy skies were increasingly introduced by Constable into his later finished paintings. Figure 44 shows another coast scene at Brighton, with a dark sky heralding the approach of bad weather.

Fig. 44 The Sea near Brighton

OIL ON PAPER, 17 x 24 CM. 1826. LONDON, TATE GALLERY

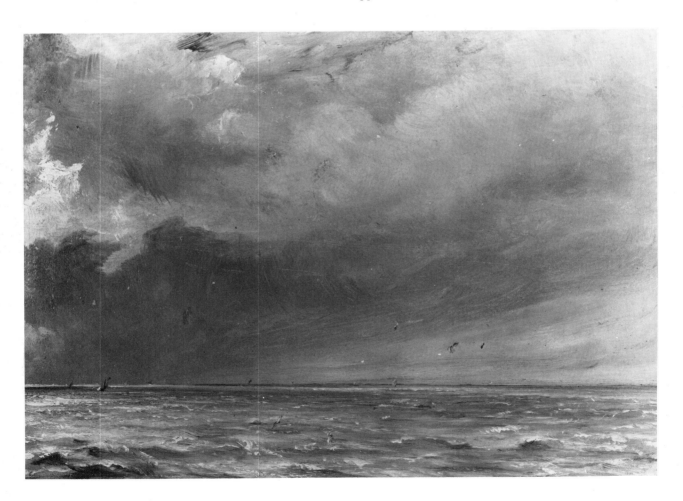

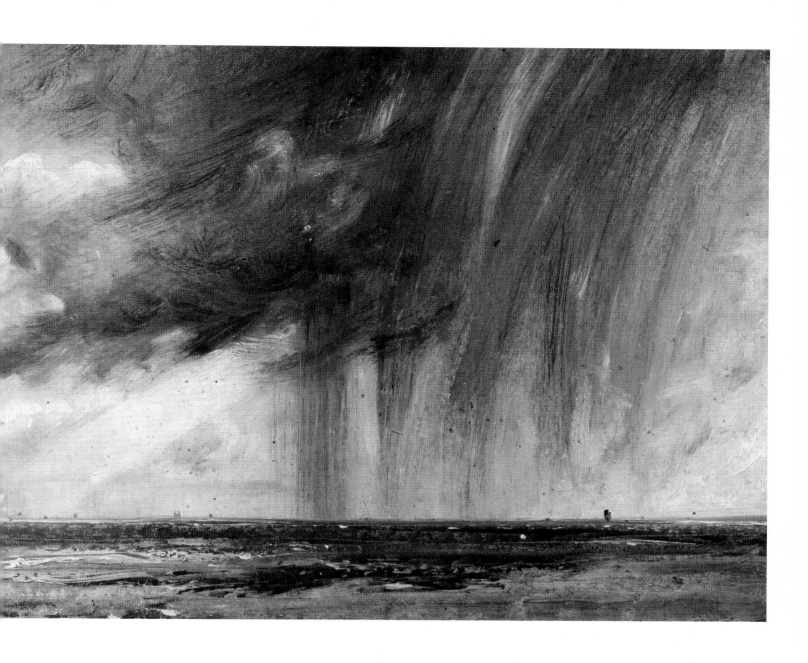

Salisbury Cathedral from the River

CANVAS, 53 x 77 CM. 1820s. LONDON, NATIONAL GALLERY

Constable first stayed at Salisbury, with Bishop Fisher, in September 1811, and it was at this time that he formed the close friendship with the Bishop's nephew, John Fisher, that was to be such a support to him, as well as being the occasion of those letters from Constable to Fisher that reveal so much about his art. From 1811 onwards Constable visited Salisbury on a number of occasions until 1829, and it was from Salisbury that he made some excursions to Gillingham, of which John Fisher became vicar in 1819. This provided Constable with the subject of *Gillingham Mill* (Fig.45) exhibited at the Royal Academy in 1827. The illustrated oil study of Salisbury cathedral, dating from the 1820s, shows Constable continuing to make vigorous sketches over a light brown ground, similar to the kind he had developed over the previous two decades.

Fig. 45 Gillingham Mill, Dorset

CANVAS, 63 x 52 CM. EXHIBITED 1827. LONDON, VICTORIA AND ALBERT MUSEUM

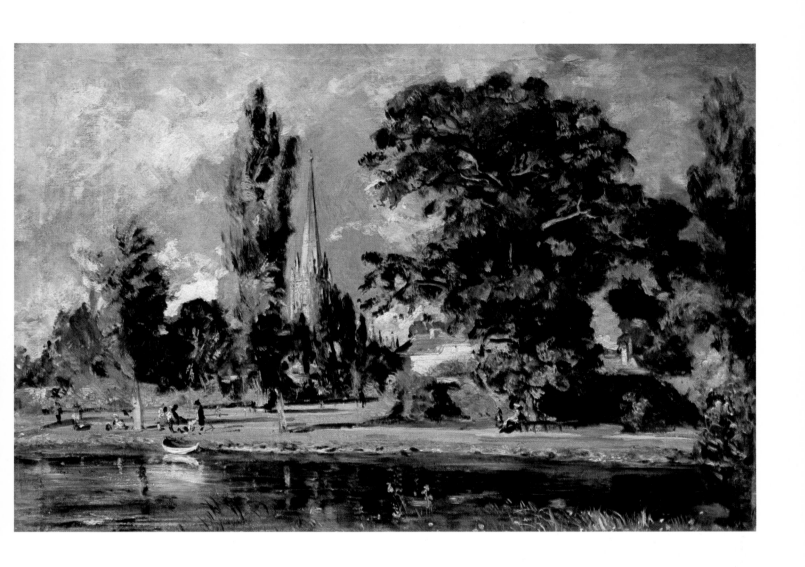

Full-Scale Study for 'The Leaping Horse'

A drawing in the British Museum (Fig. 46) shows an early idea for the composition, which is quite close to the full-scale study. The finished painting, when exhibited, may have had two willow stumps, on either side of the horse, but afterwards Constable painted out the one on the right; and in the full-size study there is evidence to suggest that this also at one time had two willow stumps, the left one having been painted out in this case. What is clear is that Constable had frequent periods of doubt and hesitancy as the composition developed. On 5 January, 1825, he wrote to Fisher, 'I am writing this hasty scrawl before a six foot canvas – which I have just launched with all my usual anxieties. It is a canal scene' The full-scale study is heavily worked up in comparison to the thinly painted study for the *Haywain*, and it may be that both sketch and finished painting were being worked on at the same time, with some doubt as to which should become the finished painting. There is evidence of frequent changes in both compositions and Constable possibly used the two paintings to work at the same time on alternative compositional ideas. It also seems possible that as Constable grew older the extensive working and reworking of a canvas and the resultant complex texture of paint layers took on a meaning of its own for him, so that he found it difficult to stop adding to the depth and richness of his work.

Fig. 46 Drawing for 'The Leaping Horse'

CHALK AND INK WASH, 20.5 x 30 CM. 1824–5. LONDON, BRITISH MUSEUM

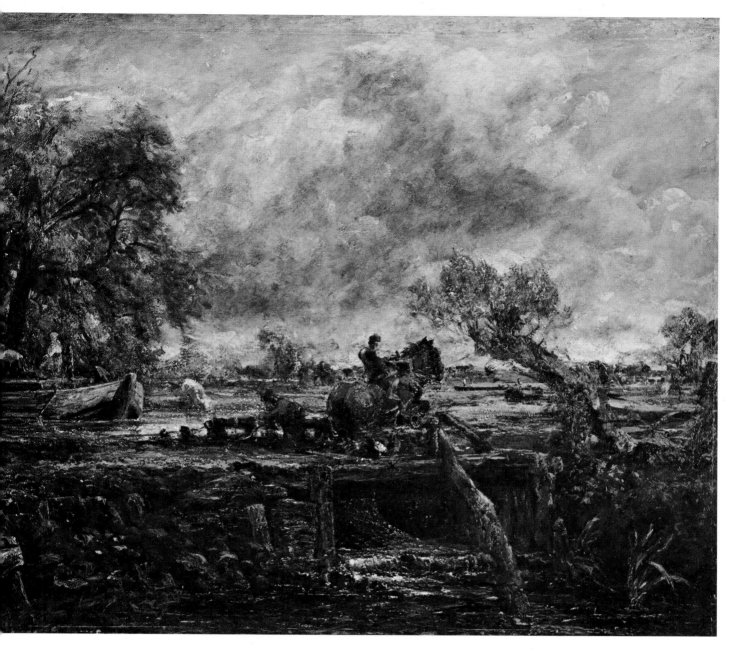

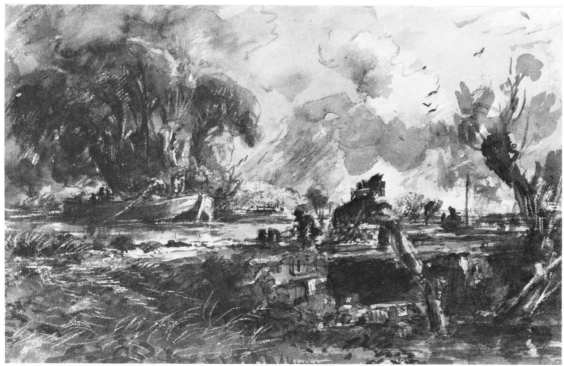

The Leaping Horse

CANVAS, 136 x 180 CM. 1825. LONDON, ROYAL ACADEMY OF ARTS

Next to the *Haywain* (Plate 23), this is probably the most famous of Constable's compositions. It illustrates a feature of Stour valley working life, when a horse pulling its barge had to leap one of the barriers set across the towpath to prevent the cattle from straying from one field into another. There are developments in the style and composition of this picture, exhibited at the Royal Academy in 1825, which show some significant changes from the *Haywain*. Constable introduced so many changes to the composition, both before and after the painting was exhibited, that there is no longer that kind of minute topographical accuracy that is found in his earlier works. But it was, nonetheless, for Constable, essentially the Stour, and so in the finished work the tower of Dedham church has been included on the far right, executed with a degree of detail that is not apparent in the rest of the picture. The composition, with the upper part of the horse and its rider silhouetted against the sky, has a drama and monumentality hardly seen before this date in Constable's finished paintings. This is partly caused by the unusually low viewpoint which Constable adopts here, allowing horse and barge and trees to rise majestically before the spectator.

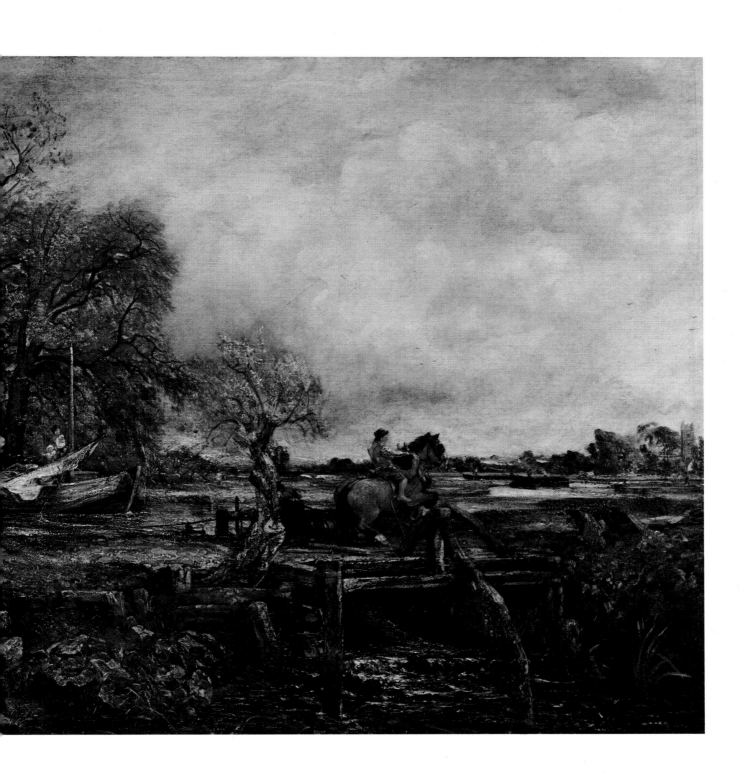

Detail from 'The Leaping Horse' (Plate 37)

This detail from the finished painting of *The Leaping Horse* shows Constable's complex, dense and vibrant brush-strokes. Note especially the area immediately above the stern of the barge, where there seems to be almost an explosion of white pigment against the dark background.

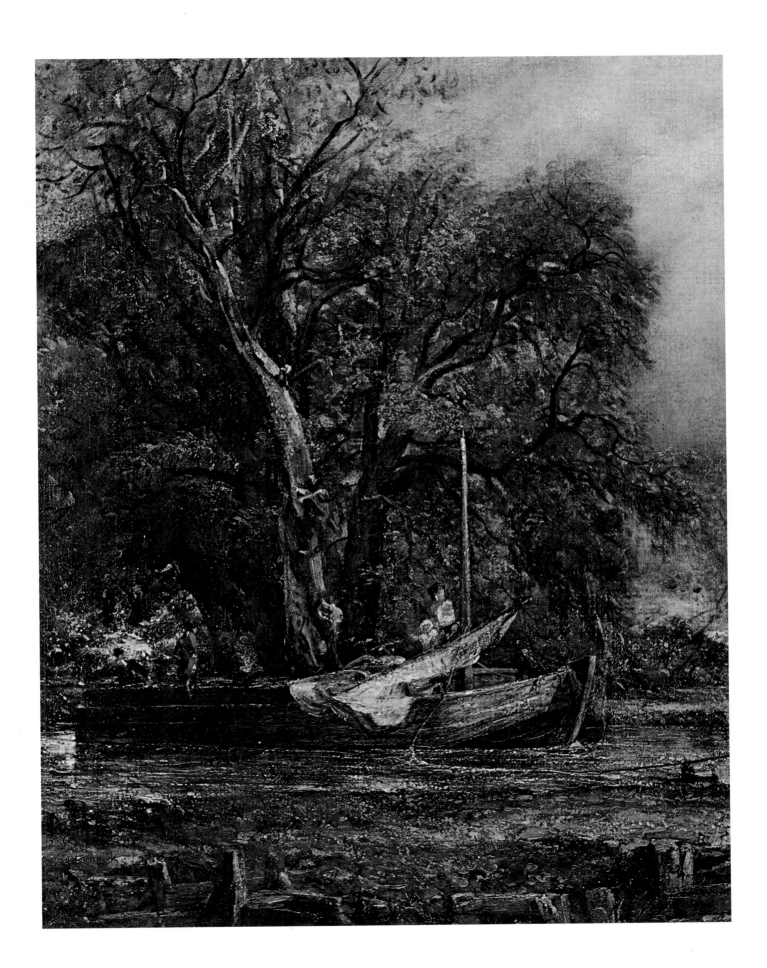

The Cornfield

CANVAS, 143 x 122 CM. 1826. LONDON, NATIONAL GALLERY

This picture was exhibited at the Royal Academy in 1826. It shows the lane from East Bergholt, which led to the path across the fields to Dedham, the way which Constable would have walked to school as a boy. The small church tower in the distance seems to be an invention. Constable was particularly careful in this picture to describe the different kinds of trees. He wrote to John Fisher on 8 April, 1826, 'The trees are more than usually studied and the extremities well defined – as well as their species – they are shaken by a pleasant and healthful breeze.' Constable used the dog that appears in the *Cornfield* again later in *Salisbury Cathedral from the Meadows* (Plate 44). The *Cornfield* is a more carefully finished work than is usual with Constable at this date, when he was moving away from exactness of detail towards a rougher finish, but it may have been in this case partly intentional. He wrote to Fisher, 'I do hope to sell this present picture – as it has certainly got a little more eye-salve than I usually condescend to give them.' It may also have been this degree of finish that helped to decide a body of subscribers to buy it from his executors in 1837, for in fact Constable did not sell it, and donate it to the National Gallery, as the first of Constable's works to enter a public collection.

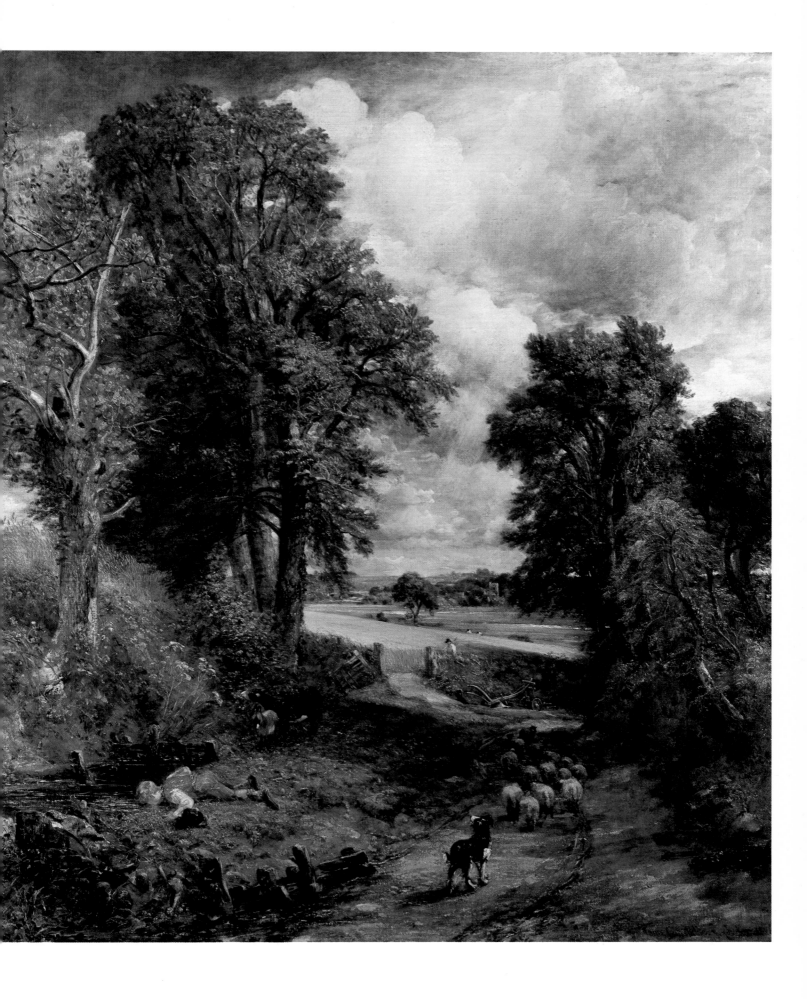

Detail from 'The Cornfield' (Plate 39)

The black donkey which browses on the left of this detail of *The Cornfield* appears also in an earlier painting, *Dedham Vale: Morning* (Fig. 47), which was exhibited at the Royal Academy in 1811 and is one of his most beautiful early finished paintings, with a breathtaking soft morning light bathing the Stour Valley. There is also a study of the donkey with its foal in the Victoria and Albert Museum. Constable frequently used and re-used such motifs in his work, sometimes much later in life going back to earlier sketches and paintings. The inclusion of such 'picturesque' elements as donkeys in his pictures may have been partly intended to please prospective clients, but they were also seen by Constable as representative of the humble nature which he championed in his art.

Fig. 47 Dedham Vale: Morning

CANVAS, 78.5 x 129.5 CM. 1811. PRIVATE COLLECTION

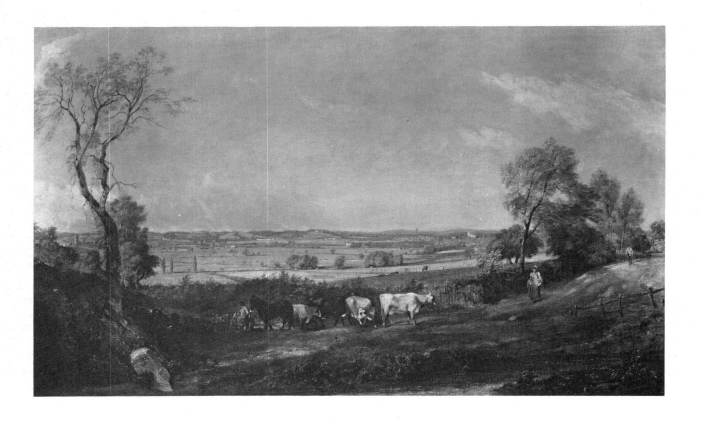

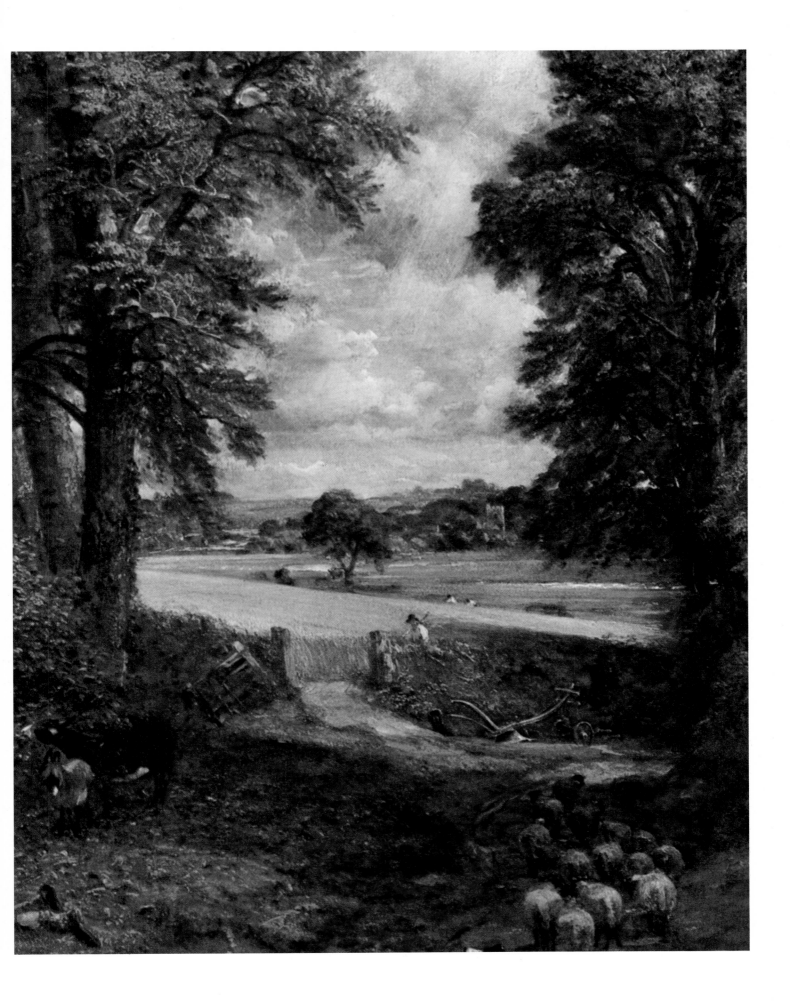

Marine Parade and Chain Pier, Brighton

CANVAS, 127 x 185 CM. 1826–7. LONDON, TATE GALLERY

Constable's frequent trips to Brighton in the mid 1820s to visit his wife obviously suggested the subject of this painting, which was exhibited at the Royal Academy in 1827, and was his only major finished painting of Brighton. In fact it was the first of his exhibited 'six-footers' to show a subject other than a Stour valley scene. Constable wrote to the dealer, Dominic Colnaghi, on 6 April, 1827, saying, 'Fisher rather likes my coast, or at least believes it to be a useful change of subject.' Constable liked the sea and sky at Brighton, but found all the paraphernalia of the fashionable resort distasteful and even found the fishing boats disturbing, because '. . . these subjects are so hackneyed in the Exhibition' and had become the subject of a 'picturesque' genre, which he found shallow. He wrote that 'The magnificence of the sea, and its . . . everlasting voice, is drowned in the din & lost in the tumult of stage coaches – gigs – "flys" &c. – and the beach is only Piccadilly . . . by the sea-side.' The subject, however, gave him the chance to produce a really magnificent sky.

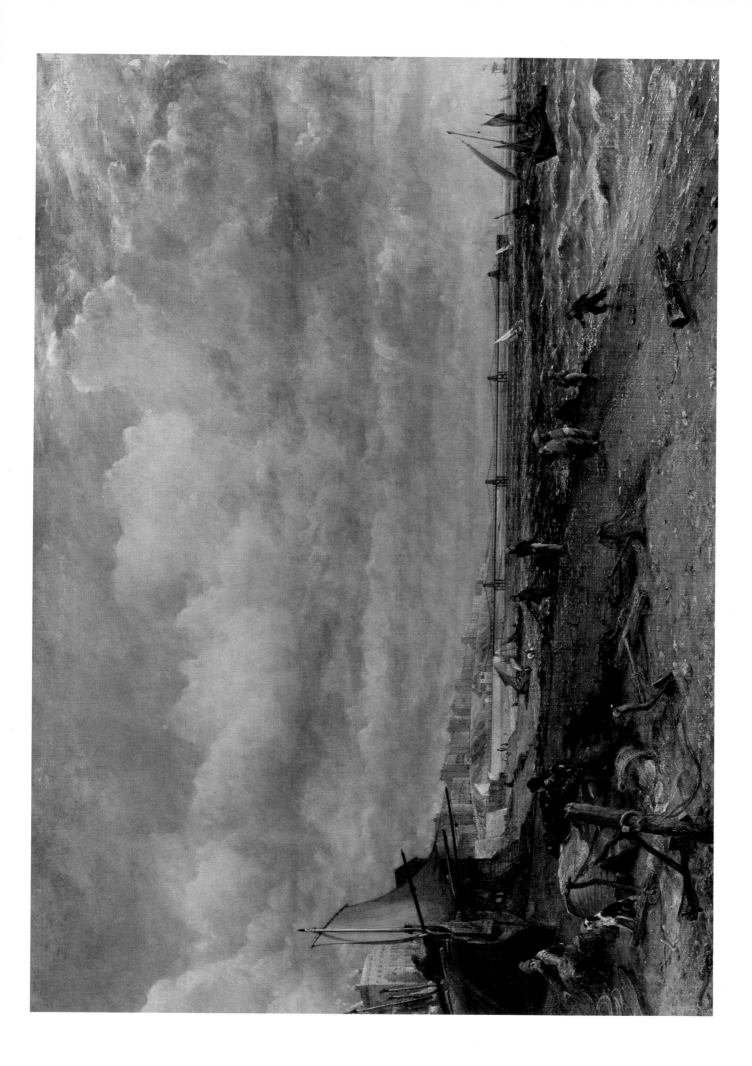

Hampstead Heath: Branch Hill Pond

CANVAS, 60 x 77 CM. 1828. LONDON, VICTORIA AND ALBERT MUSEUM

This painting of Branch Hill Pond, which lay just below Judge's Walk and now no longer exists as water, is based on an oil sketch in the Victoria and Albert Museum done in 1819 (see Fig. 39). Constable, especially in later years, frequently returned to earlier sketches as a basis for finished paintings. This painting was exhibited at the Royal Academy in 1828 at the same time as the *Dedham Vale* (Fig. 16) in the National Gallery of Scotland, the composition of which is also based on a much earlier sketch, the *Dedham Vale* of 1802 (Plate 3). The Branch Hill Pond painting was engraved by Lucas in mezzotint for Constable's *English Landscape Scenery* and published in September 1831. The workmen appear to be excavating sand from the hillside. Compared with the earlier painting of *Hampstead Heath* (Plate 22) this is far more dramatic and sombre, with a richness and depth of shadow and a stormy sky matched by the far more impassioned quality of the brushstrokes. It is one of Constable's favourite compositions of Hampstead Heath, which he repeated a number of times.

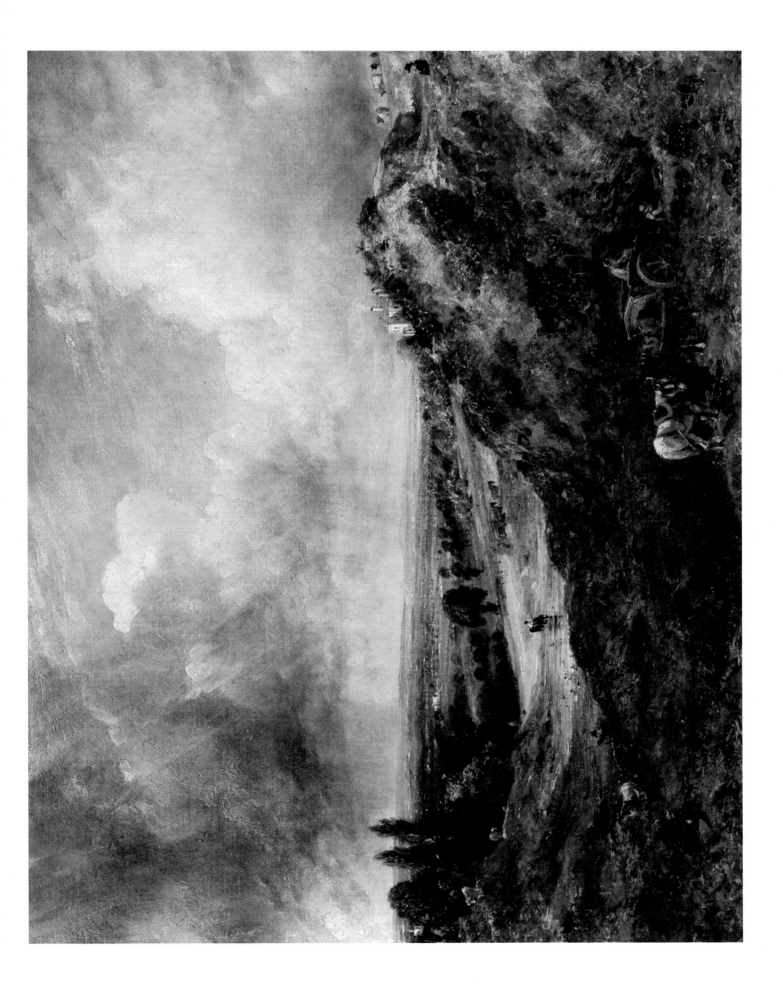

Full-Scale Study for 'Hadleigh Castle'

CANVAS, 123 x 167 CM. 1829. LONDON, TATE GALLERY

The composition of Hadleigh Castle was based on a pencil sketch made in 1814, the only time, as far as is known, that Constable visited this place on the Essex coast. The full-size sketch and the exhibited finished painting (Fig.48), now in the Yale Center for British Art, show how Constable in the second half of the 1820s moved away from the very local and particular atmosphere of the Stour valley paintings towards aspects of nature that were more dramatic and more generalized, evoking moods that were more universal. He accompanied the catalogue entry, as he sometimes did, with lines of poetry, in this case Thomson's *Summer,* expressing a wild and restless view of ruins, sea and glittering light. Possibly the melancholy nature of the scene, with the ruined castle, reflects his despair after the death of his wife in 1828 as well as his more cosmic view of landscape. The concern with ruins and the wilder aspects of nature found in *Hadleigh Castle* is found again in the watercolour of *Stonehenge* (Fig. 12), which Constable exhibited at the Royal Academy in 1836.

Fig. 48 Hadleigh Castle. The Mouth of the Thames – Morning, after a Stormy Night

CANVAS, 122 x 164.5 CM. EXHIBITED 1829. NEW HAVEN, CONNECTICUT, YALE CENTER FOR BRITISH ART (PAUL MELLON COLLECTION)

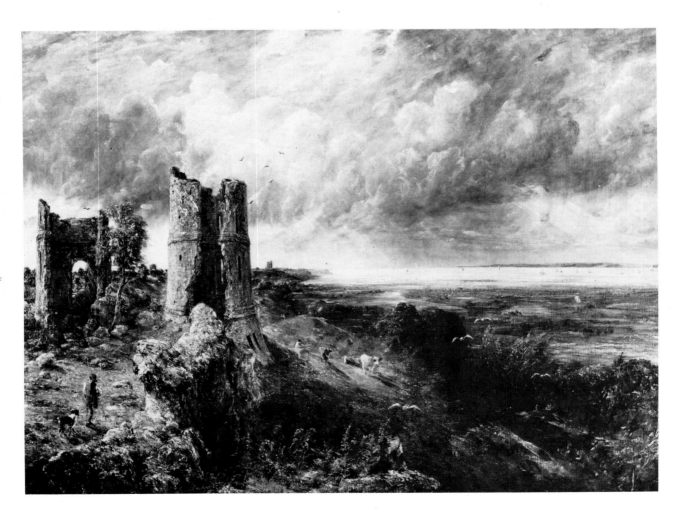

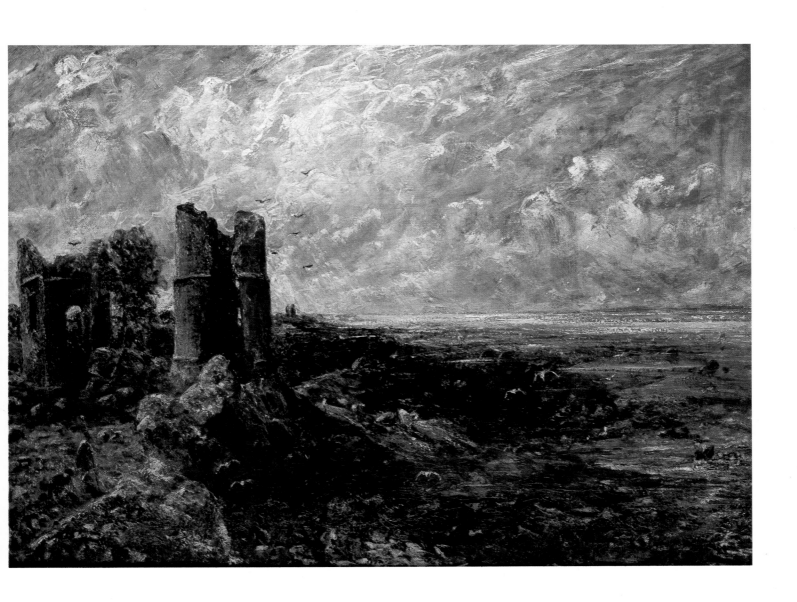

Salisbury Cathedral from the Meadows

CANVAS, 147 x 189 CM. 1831. PRIVATE COLLECTION

A painting of Salisbury Cathedral from the Bishop's Grounds, now in the Victoria and Albert Museum, was commissioned by the Bishop and exhibited at the Royal Academy in 1823. This showed a detailed depiction of the Cathedral from the south, with a gothic arch of trees in the foreground framing the spire. The illustrated painting, exhibited in 1831, was the last major work that Constable painted of Salisbury and it is quite unlike the earlier painting. It was not a commissioned work and in many ways it sums up in an almost cosmic way Constable's feelings about nature as God's revelation. The paintwork is thick and dense, though also delicate, striking the eye somewhat as the power and complexity of musical chords in music do the ear. The rainbow towers above the church, suggesting hope and the colours of nature, while the cathedral represents the church, with a black cloud above it. The landscape represents the natural world and the waggon, in almost classical profile, echoes, but in a more monumental way, the subject of the *Haywain*. It may be impossible to prove this somewhat symbolic interpretation of the painting in terms of Constable's own intentions, but the overall monumentality of the composition, with its distinct elements, seems to argue for a much more generalized conception of landscape than the intensely localised character of his earlier works. Details from earlier paintings reappear, the black and white dog from the *Cornfield* (Plate 39) and the boat from the *Haywain* (Plate 23). These are features that underline the fact that Constable's large paintings, and especially his later ones, were created in the studio from sketches and recollections and memories. They were not the result of one direct confrontation with a landscape, but of a gradual build up in his mind over many years of his experience of nature.

View at Hampstead, Looking towards London

WATERCOLOUR, 11x19CM. 7 DECEMBER 1833. LONDON, VICTORIA AND ALBERT MUSEUM

The watercolour is inscribed on the back, 'Hampd December 7, 1833 3 o'clock – very stormy afternoon – & High Wind'. It shows the view from one of the back windows of No. 6, Well Walk, Hampstead, where Constable lived after 1827, looking towards the City with St. Paul's dome looming in the cloudy distance.

Constable continued noting the times of day on his drawings and sketches throughout his life. (Fig. 49) *View over London with a Double Rainbow* is inscribed on the back 'between 6. & 7. o'clock Evening [? June] 1831'. Constable was fascinated by rainbows, and this unusual effect was sketched at Hampstead in the same year in which he had exhibited *Salisbury Cathedral from the Meadows* at the Royal Academy. This painting (Plate 44) also includes a dramatic rainbow.

Fig. 49 View over London with a Double Rainbow

WATERCOLOUR WITH SCRAPING-OUT, 19.5 x 32.5 CM. 1831. LONDON, BRITISH MUSEUM

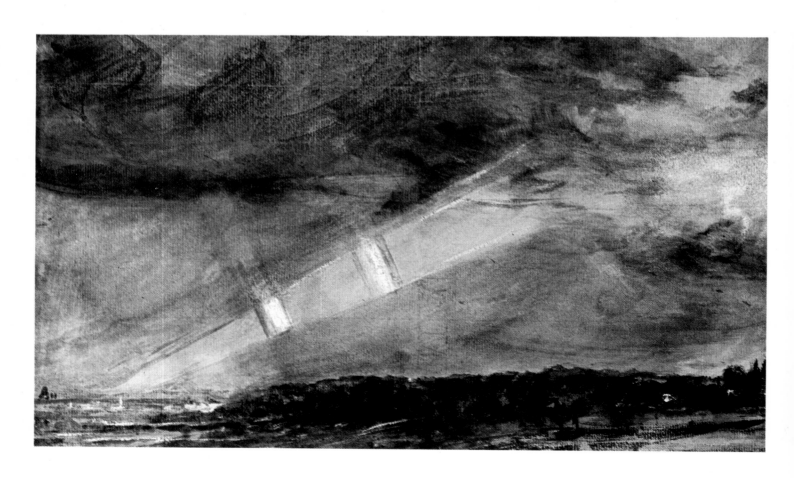

The Valley Farm

CANVAS, 149 x 126 CM. 1835. LONDON, TATE GALLERY

The Valley Farm is a late painting in which Constable's vision of the Stour valley can be seen to be conditioned by nostalgia and the effects of distance in place and time. The rural scene has become almost monumental. Willy Lott's house now appears like a half-timbered mansion. The tree with the silvery branches on the right is based on a drawing of an ash tree (Fig. 50), probably made from studies which Constable drew at Hampstead, although it could also possibly be based on studies of ash trees at East Bergholt made by John Dunthorne junior; Constable wrote to John Dunthorne senior on 14 February 1835, asking to borrow his late son's studies, saying, 'I am about an ash or two now.' Brown autumnal tints predominate. As was often the case, Constable worked on the picture long after the exhibition at the Royal Academy. In October 1835, he wrote that 'Oiling out, making out, polishing, scraping, &c. seem to have agreed with it exceedingly. The "sleet" and "snow" have disappeared, leaving in their places, silver, ivory, and a little gold.'

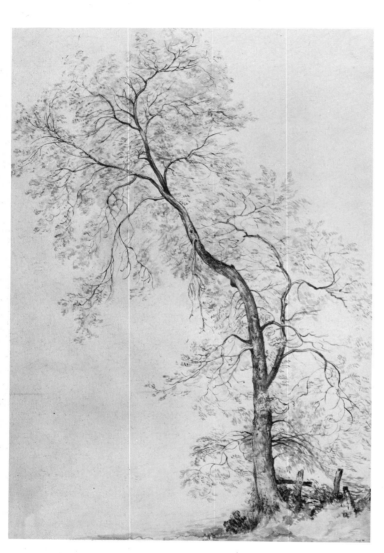

Fig. 50 Drawing of a Tree

PENCIL AND WATERCOLOUR, 99 x 68 CM. C.1835. LONDON, VICTORIA AND ALBERT MUSEUM

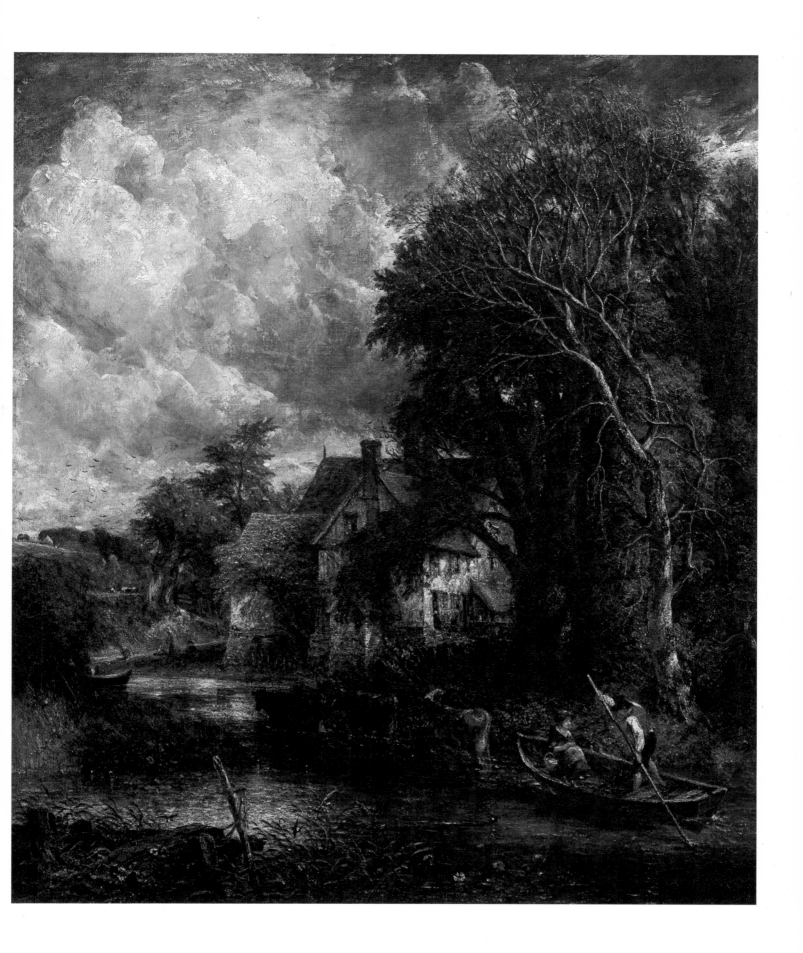

A River Scene with a Farmhouse near the Water's Edge.

CANVAS, 25 x 35 CM. C.1830–6. LONDON, VICTORIA AND ALBERT MUSEUM

The extent to which Constable's brushwork became freer and more impassioned in his last years, though also, in a curious way, decorative, can be seen in this painting and in the comparable, though perhaps stronger, painting of the *Cottage at East Berghol* (Fig. 51) of the same period. Constable would probably not have thought of exhibiting such paintings, though he would have seen them as finished works rather than sketches. They have a generalized quality, for though they include recognizable, or nearly recognizable features from his earlier Stour valley paintings, they clearly aim to capture the emotional essence of such scenes, rather than to depict specific topographical locations. The clouds and trees have lost some of their realistic structure and the borderline between paint, for its own sake, and its representational purpose has become blurred.

Fig. 51 Cottage at East Bergholt

CANVAS, 83.8 x 110.5 CM.? 1835-7. PORT SUNLIGHT VILLAGE, LADY LEVER ART GALLERY

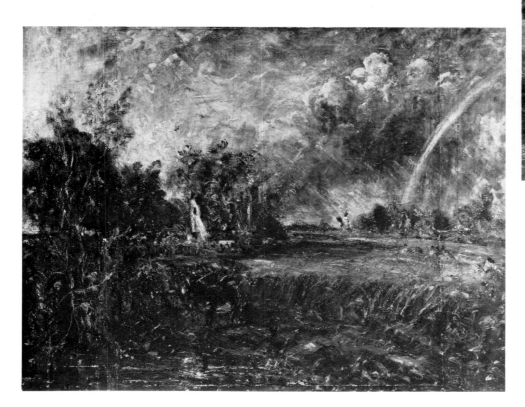

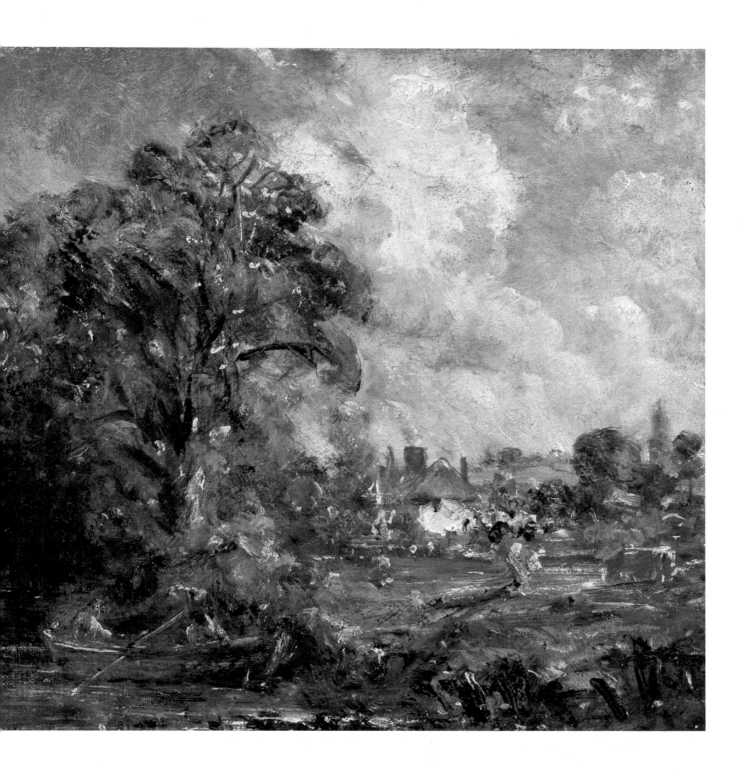

Trees and a Stretch of Water on the Stour

PENCIL AND SEPIA WASH, 20 x 16 CM. C.1830–6. LONDON, VICTORIA
AND ALBERT MUSEUM

This is a late and rather unusual wash drawing done on the
same sheet of paper as another similar study. The paper has
been cut in two and both drawings are in the Victoria and
Albert Museum. The fact that both drawings are variations
on earlier compositions suggests that they may have been
done as exercises indoors. Constable has here, in his last
years, concentrated on the very broadest massing of light
and shade in an attempt to describe the dramatic
'chiaroscuro' of nature.

A Tree Growing in a Hollow (Fig. 52), dated 16 July,
1835, and part of a sketchbook Constable used in Sussex in
this year, shows how his pencil drawing could also be ex-
tremely free and expressive in his last years.

Fig. 52 A Tree Growing in a Hollow

PENCIL, 11.5 x 18.8 CM. INSCRIBED 'FITTLEWORTH 16 JULY 1835'. LONDON,
VICTORIA AND ALBERT MUSEUM

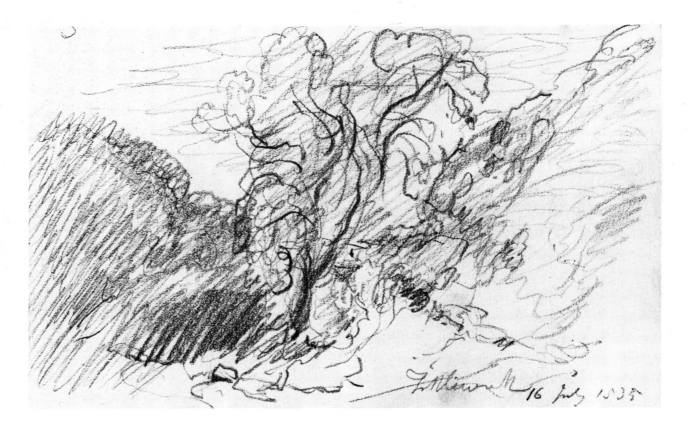